HOW TO DRAW
Stupid

KYLE BAKER

HOW TO DRAW
Stupid
AND OTHER ESSENTIALS OF CARTOONING

Kyle Baker

Watson-Guptill Publications / New York

Text Copyright © 2008 by Kyle Baker

Art Copyright © 2004, 2005, 2006, 2008 by Kyle Baker

Executive Editor: Candace Raney

Editor: James Waller

Designer: Melissa Chand

First published in 2008 by Watson-Guptill Publications,

Nielsen Business Media,

a division of The Nielsen Company

770 Broadway, New York, NY 10003

www.watsonguptill.com

ISBN-10: 0-8230-0143-1

ISBN-13: 978-0-8230-0143-9

Library of Congress Control Number: 2008922161

Watson-Guptill Publications books are available at special discounts when
purchased in bulk for premiums and sales promotions, as well as for fund-
raising or educational use. Special editions or book excerpts can be created
to specification. For details, please contact the Special Sales Director at the
address above.

The stories, characters, and incidents mentioned in this book are entirely
fictional. All characters featured in this book and the distinctive likenesses
thereof are trademarks of Kyle Baker.

Printed in China

First printing, 2008

1 2 3 4 5 6 7 8 9/12 11 10 09 08

This book is dedicated to the
future cartoonists of the universe.

To Walter Simonson, Howard Chaykin, Jack Abel, Joe
Rubinstein, Al Milgrom, Dick Giordano, Bill Sienkiewicz,
Frank Miller, Jim Shooter, Howard Beckerman, John
Romita Sr., and Robert Simpson—thanks for teaching me.

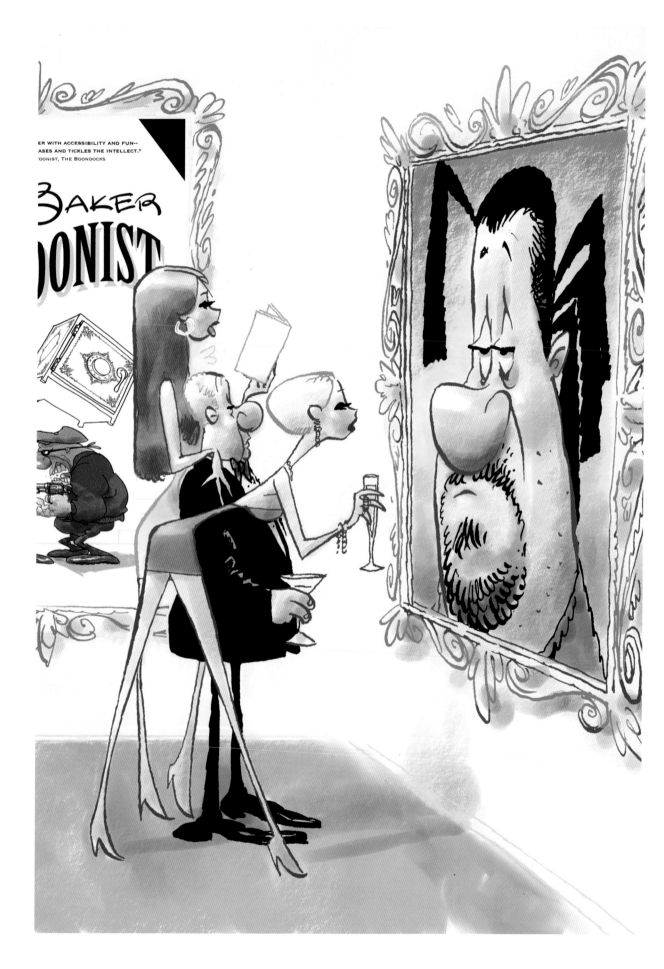

CONTENTS

Cartooning—The Kyle Baker Way

There's more to being a cartoonist than just cars, jewels, and romance, but not *much* more.

This instructional book will teach you what you need to know to become a universally beloved, world-renowned, funny cartoonist who creates comics, graphic novels, and animation for movies, TV, the Internet, and any and all existing and future technologies throughout the universe . . . the Kyle Baker way.

And what a way!

———◆———

I was once just like you. People used to kick sand in my face at the beach. Not on purpose. I was three years old, and I don't really think they knew they were doing it. My point is, *I had a dream!* A dream of being a for-real cartoonist just like the guys whose work I saw in the newspapers and on TV cartoons. While other kids my age wanted to be the Yankees' Reggie Jackson, I wanted to be Johnny Hart, the *B.C.* cartoonist. May he rest in peace.

I'm gray-haired now, but I still remember the first time I saw Walt Disney's *Snow White.* I was about five, and it was showing at Lincoln Center. At that moment I decided what I was going to do with my life.

To this day, folks try to talk me out of it. When I was young, well-meaning adults would explain to me that it was impossible to make a living as a cartoonist. When I got older, well-meaning publishers, editors, and animation producers would tell me that it just wasn't possible to publish or produce the kinds of cartoons I like to make.

Now, I never finished college, but I've always known one thing: If somebody's done a thing once, that proves it's possible. Whether it's walking on the moon or winning an Oscar or making a beard out of killer bees, if someone's done it, it *can* be done. All you have to do is find out how they did it and then do the exact same thing.

This book tells you how I do what I do.

I've discovered that a significant percentage of my fans are themselves professional cartoonists—the people who make the animation we see on TV and in movies. When I walk around the Disney lot, animators yell, "There goes Kyle Baker!" and wave. I bring this up because I'm assuming that many of the people who will read this book are actually experienced professionals, so I'll be glossing over some of the basics and offering tips that are slightly more advanced than those you might find in other cartooning books. That's not to say that this book has no value for beginners. Anybody who reads this book and makes use of the knowledge dispensed herein shall experience the ability to cartoon the Kyle Baker way . . .

So prepare to be the life of the party!

CHAPTER

Do a Cartoon!

To be a cartoonist, you must actually *make cartoons*. I bring this up because I've met a lot of people who say they want to be cartoonists, but they don't have any cartoons.

Or they have cartoons but they won't show them to anybody. Whatever the case, this general cartoonlessness is a significant enough syndrome to warrant my devoting a chapter to its analysis and cure.

I believe it has to do with a fear of rejection. Such people usually mutter something to this effect when I call attention to their lack of cartoons.

To such mutterances I reply, "Dude, it's a freakin' *cartoon*!

You have to actually *make* something, even if it's bad. Doing stuff wrong is how you learn to do it right. I deliberately do things I'm bad at, just so I can get better at them.

The fastest way to learn cartooning is to imitate other cartoonists. Just sit down and copy—or even trace—your favorite cartoonist's work, line for line. Why not? You have to start somewhere.

Do you know why I'm a cartoonist? Zero startup cost! All you need is a pen and some paper! How hard is it to get a pen and paper? You can steal them from a bank, and they won't care!

I don't remember the first cartoon I ever did, because I was just a baby, but I bet that cartoon was *lousy*. Do you know how I know this? Because my first published cartoon was lousy!

Have you ever seen a really bad cartoon on TV and asked yourself, "How did that cartoonist get a TV show?" Well, I'll tell you one reason. He got it because he actually did some cartoons. So do one!

Sometimes, people who want to be cartoonists (but don't have any cartoons) expect that somebody will pay them before they actually draw anything. They think they can get somebody to give them money them up front if they just verbally describe their cartoon idea. They imagine that the editor or producer will be sufficiently moved by this oratory to finance the production of an actual cartoon.

There's a flaw in this logic. The flaw is that it's impossible to describe a good cartoon:

"Okay, so the mouse hits the cat in the face with a frying pan, which makes the cat's head into a frying pan shape! And it makes this great sound, like a crashing metallic sound! Then the cat does this funny staggering walk, and he's cross-eyed and making funny faces, and then he falls in the swimming pool, and when he comes out his hair is all wet and he looks really funny, 'cause his hair's all like, you know, hanging down. And wet."

Trust me. This *could* be funny. If I animated it, it would be hilarious.

Especially if the cat looked like this:

Unfortunately, the only things that get approved and financed in advance are things that can be easily described. That's why cartoons talk so much now.

I don't like working that way. I prefer to do the cartoon *first* and then to try to sell it. If the first editor or producer I pitch it to doesn't like it, I keep going till I find somebody who does.

That's a lot better than having to let some idiot ruin your cartoon because he's already paid you, and you've already spent the money. (Though I confess that I've done that, too.)

Sometimes you just have to do what's necessary to avoid getting a "real" job. Which brings us to the next chapter . . .

Never Have a "Plan B"

For twelve years, my teachers kept telling me to shape up. I used to stop by the school mailroom daily to intercept letters written to my parents so that I could forge their signatures on the reports they never received. My drawing skill sure came in handy for that!

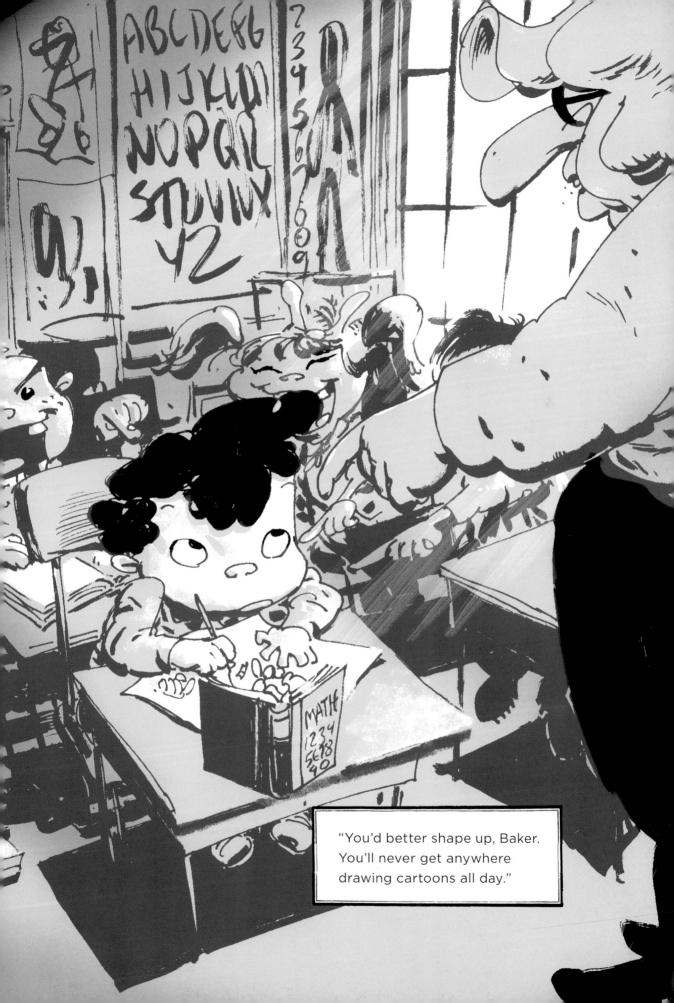

"You'd better shape up, Baker. You'll never get anywhere drawing cartoons all day."

ART

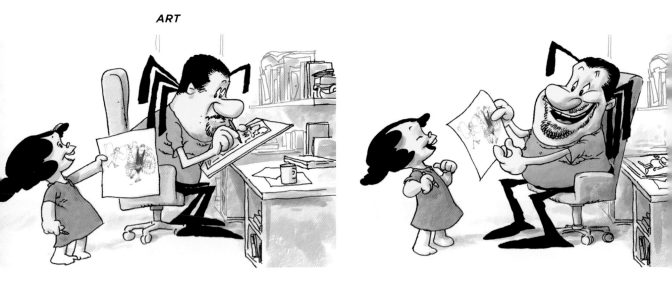

Something was clearly wrong with me. I ignored almost every word my teachers and other adults said. If only I had a dollar for each time I was told I was living my life wrong, "wasting my potential," royally screwing up my life. (Actually, I do have a dollar for each of those times.) Anyway, my point is, I *knew* what I wanted to do with my life, and I never settled for less.

Somebody's always going to tell you that you can't do something. They are wrong.

I mostly got Cs and Ds in school. I only got two Fs. The subjects I failed were art and English. Think about that. I failed art twice—the second time was in college just before I dropped out and became a world-famous cartoonist.

In retrospect, I understand that I flunked art and English because those were the two areas in which I was most creative. School rewards those students who can memorize and repeat exactly what the teacher tells them. Grades are based on exams that measure your ability to repeat memorized answers within a limited time frame. That meant that if the bell rang before I solved a problem I needed more time on, I failed.

My painting teacher told me to paint a certain object using his specific method. I painted it my own way and got an F. I doubt you'll be reading *his* book any time soon. So-called teachers would constantly point to the most creative parts of my artwork and call them mistakes—the same elements that fans call my "style." I got D's in creative writing classes. The grammar and spelling were fine, but the teacher didn't like what I wrote. The *creative* part.

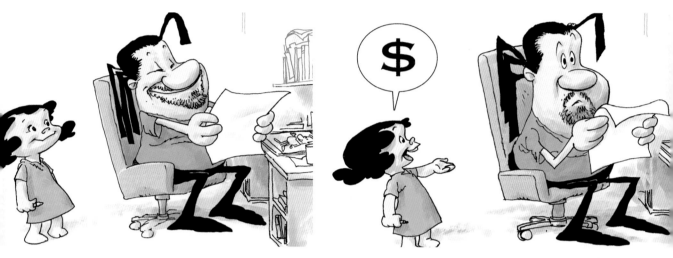

College was helpful. Not because of anything I learned in class, though. Going to college forced me to learn how to earn money! I didn't have any scholarships. I was a D student! Nobody was going to invest six figures in sending me to college! Since the only thing I knew how to do was draw, I paid for my tuition by drawing Spider-Man for Marvel Comics. Then I realized I already had the cartooning career I was supposedly studying for, so I dropped out.

Idiots recommend learning some other career "to fall back on" in case the cartooning doesn't work out. Does anybody give that advice to aspiring bus drivers? "Learn something harder to do in case the bus-driving thing doesn't work out. Like rocket science." It's harder to become a CPA than a cartoonist, so why not do the easier thing? Especially if it makes you happy.

Making cartoons is easy. After all, they're *cartoons*! If you learn how to do it right, you will succeed.

There are some professional cartoonists who hate their jobs. I'm not talking about rookies. When I was a beginner, I did the crummy jobs nobody wanted to do. That's normal. That's education and paying your dues. I'm talking about the guys and gals working as professional cartoonists who are always complaining about how much they hate the cartoons they work on.

Why on earth are they working on cartoons they hate? It couldn't possibly be for the money. If I were going to do a job I hated just because I needed money, I'd sell weapons. It pays better than cartooning.

Choose the Right Tools

When you visit an art supplies store, you see that there are many different and exciting tools for making artwork. Besides the boring pencils and markers that are available at any drugstore or supermarket, a real art supplies store has oil paints, acrylics, watercolors, pastels, and fancy kinds of paper: rough, shiny, smooth, colored—whatever you want!

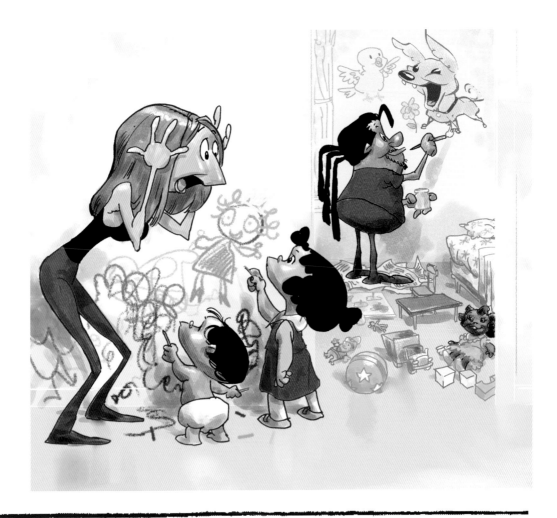

The first thing to consider when choosing your tools and supplies is the look you're going for. What emotions are you trying to generate? Is this a comedy? An action/adventure? A romance?

I choose my own tools with speed in mind: I want to do as many cartoons as possible each day. I often choose markers rather than brushes or pencils because with a marker, the ink comes out as quickly as I move my hand. Paintbrushes and pencils often skip if you move too quickly.

I also like to use a computer for coloring my images because I am working for mass reproduction. Often, a painted image will look substantially different once it is scanned, color separated, and reproduced in a book. Using a computer, I have more control over the final, printed image.

Earlier in my career, price was a factor in my choices. I would buy cheap brushes. I used the most flexible pen nibs I could find, because they cost one-tenth the price of a good brush, and they gave me a brushlike line. Now, though, I use expensive markers

that are useless after I've drawn about three pages. The way I figure it, the speed I gain from using these markers enables me to do six times as much work, so it's worth paying more. Sometimes I use markers with archival-grade ink because I want to sell my work to collectors who like to buy comic book and animation originals. But sometimes it's more important to me to get a lot of art done quickly, so I choose non-archival pens and tracing vellum so I can go faster.

Don't get me wrong, though. Not all the supplies I use are expensive. I do animation storyboards on Post-It notes. It's easier to rearrange the scenes. And I like to use cheap computer paper because I can just throw it away if the drawing's bad. (I throw away a lot of drawings. That's one of the reasons I like to work fast.)

I'm also fond of using clip art that's in the public domain. That's why the illustration you're looking at here is of a type of pen I never draw with. Public-domain clip art is a great way to decorate a page and fill up space quickly. And it's really cheap.

As you figure out your style, what you want to convey, and the supplies that are best for you, it's worth noting that comic books have really changed—and can now accommodate all sorts of artwork. Back when I was a boy cartoonist at Marvel in the 1980s, comic books were printed using the cheapest, most primitive method. Even while contemporary periodicals were using computerized techniques to create color images and columns of text, comic book artists were doing all the text and color by hand.

Up until this present century comic book images were notorious for their limited palette and abominable registration. Gray tones were impossible to capture. The only art that could be effectively reproduced using these cheap methods was a dark black line on white paper, so comic book artists were encouraged to use lots of thick outlines and heavy black shapes to conceal the fact that the colors inevitably bled outside the lines and into each other. Pop artists like Roy Lichtenstein and Andy Warhol and graphic designers like Chip Kidd have celebrated these shoddy production values in their art—but their use of comic book images is ironic. Even the cartoons in bubble gum had better printing and paper! Imagine if Michelangelo had been told he could only use four colors to paint the Sistine Chapel—and that he couldn't use a paintbrush! That's what comic books were like until just a few years ago.

The good news is that comic books are now being produced with a quality comparable to fine art books. It's now possible to faithfully capture the subtle nuances of an oil painting, pastel rendering, or even a photograph. If you wanted to, you could do a comic book in the style of Vincent van Gogh or Chuck Close. My *King David* book uses color and design motifs from ancient Middle Eastern art. My *Nat Turner* books are designed to look like Civil War-era publications—and the artwork resembles Civil War photography.

To achieve some brand-new effects yourself, experiment with different paper textures and colors. Or you can get yourself a quill pen and some india ink and draw in a style that was created a century ago for the cruddiest printing imaginable. Goodness knows, that method works for a lot of people, too.

4

Learn to Draw

Before you become a cartoonist, though, you gotta learn how to draw.

Try copying the basic shapes by tracing over the light gray guidelines below:

Now you know how to draw a sphere, a cube, and a tube. Everything in the world is made of spheres, cubes, and tubes, so now that you know how to draw them, you know how to draw everything in the world! Congratulations!

Advanced Drawing Tip

Things look smaller the farther away from you they are. So draw faraway things tiny and nearby things big.

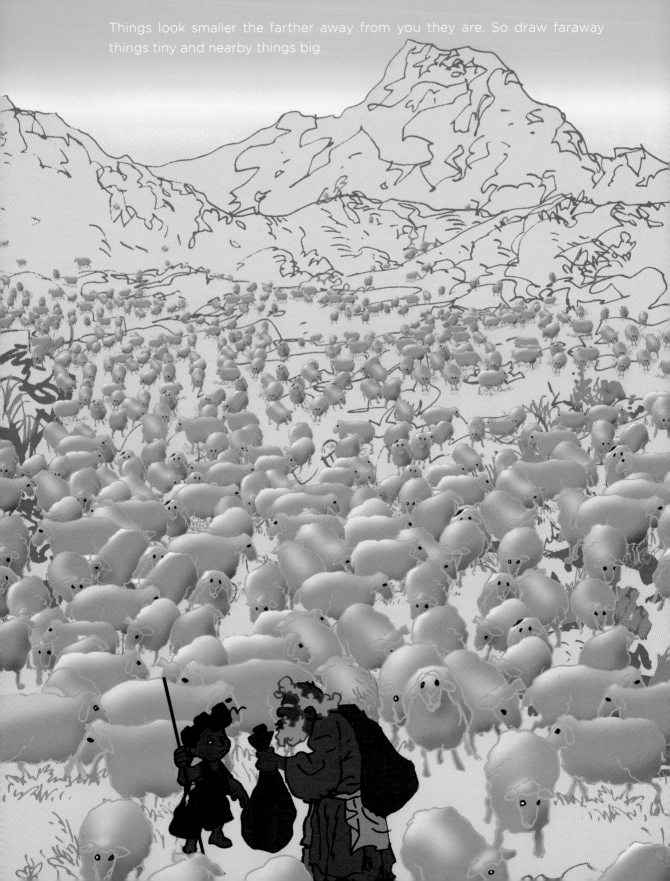

Other Hot Tips

Women are round and soft. Men are more angular. Use fewer lines when drawing women than when drawing men. That's how you can tell the difference between men and women even when they have the same hairstyle.

Women are shaped like a figure 8; men are shaped like a *V* or an *A*.

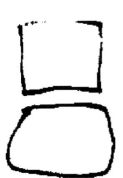

Kids have bigger heads. The bigger the head, the younger the kid.

Now you know how to draw a whole family.

Now, Forget What You've Learned

Realism is the opposite of cartooning. It's important to know the principles of good drawing to be able to communicate effectively, but the entertainment value of cartooning lies in *exaggeration.*

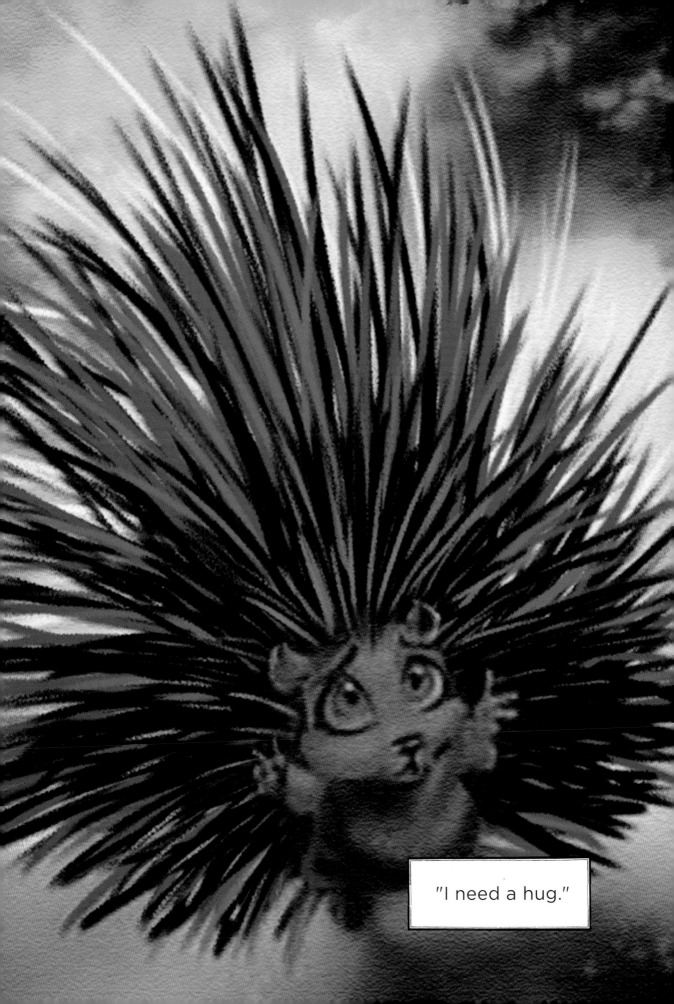

"I need a hug."

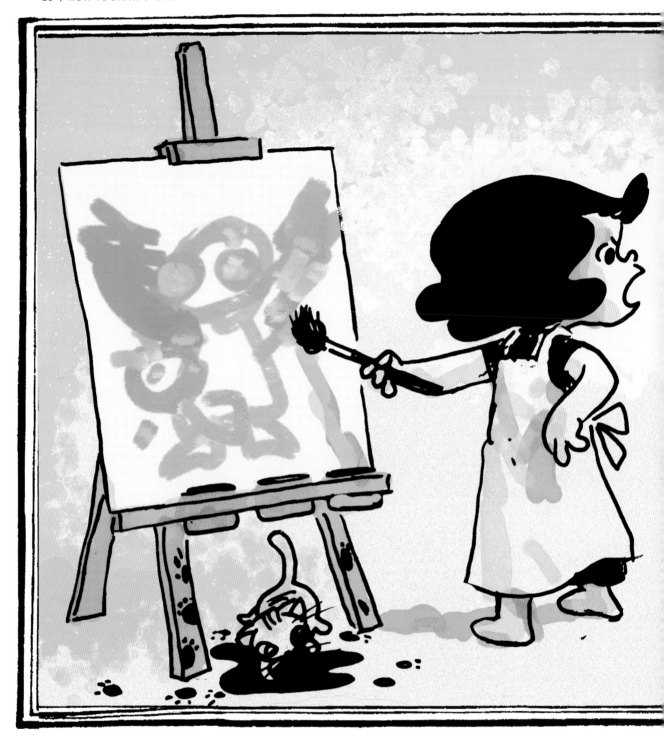

Cartoons aren't supposed to be "good." They're *cartoons*! Cartoons are all about using exaggeration in the service of communication. So to be a good, funny cartoonist, you've got to forget all that stuff you learned about drawing well.

I recently saw a "blockbuster" Hollywood animated feature at the mall. This cartoon cost $100 million to make. Every blade of grass, every leaf on every tree was lavishly rendered. I noticed that the grass itself was animated, swaying in the breeze.

"Stop moving!"

Then I realized I was staring at the background because the story was so damned boring that my attention kept wandering away from the characters. The movie failed financially because kids hated the movie. It bored them, too. It took hundreds of people and millions of dollars to make something this boring. Incredible.

I have occasionally worked in the boring factories where boring cartoons are made. I've even found myself trying to make things boring so that I wouldn't be asked to redo them in a less interesting way (which has happened often). I've found myself trying to figure out how to take six weeks to do jobs that should have taken two days, because I was being paid by the hour. Not by the laugh, not by the idea, not per drawing. By the hour. All they wanted was my time, and that's all they got. These factories are full of people who draw well. They can make a horse look like a real horse. They just can't make a horse that anybody wants to watch. When I want to see realistic horses, I go to the track.

Exaggerate to Communicate

My favorite newspaper comic strip these days is *Dilbert*. That little squiggle is more human than some of those Hollywood blockbusters that cost more than the Iraq War. Despite their limited movement, TV cartoons like *The Powerpuff Girls* and *Scooby-Doo!* are loved by millions of kids (and their parents) because of the *characters*. Not the acting or the animation, which can charitably be described as limited. (The characters hardly move, for heaven's sake!) It's the characters' personalities that we respond to. We respond to characters, emotions, and stories more than to beautifully rendered art, and when we exaggerate in a cartoon, it's to make things clearer—to be more easily understood.

Remember: Exaggerate to communicate!

Loosen Up Your Poses

Think of the body as being composed of three basic sections: head, rib-cage, and pelvis. Each of these three sections should oppose the others whenever possible.

For example, if the torso is leaning forward to the left, tilt the pelvis backward to the right. Put the left shoulder and right leg forward.

If the head is looking down, try leaning the shoulders slightly back.

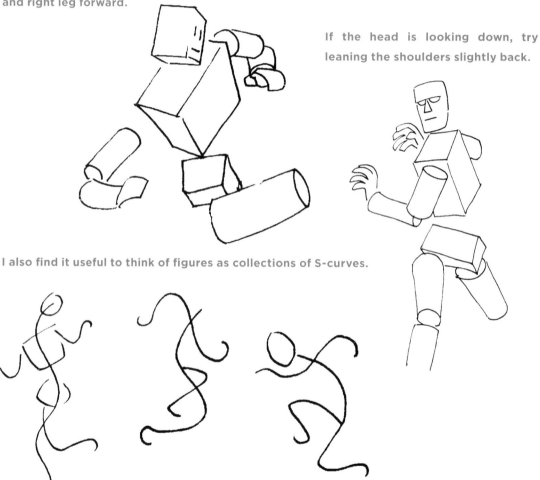

I also find it useful to think of figures as collections of S-curves.

The drawings at the top, opposite, show a typical comic book fight. To create an illusion of movement, it helps to have the characters' limbs alternate from frame to frame. In the first drawing, on the left, the character on the left is leading with his right fist and right leg, so . . . in the next drawing, he leads with the left fist and left leg. And in the last drawing, the angle from which the action is portrayed changes. Notice how, in these drawings, the principle of alternating limbs is combined with the principle, discussed earlier, of opposing the three basic sections of the body.

By the way, this technique also works well for adding movement to quieter scenes, like a business meeting or lunch-counter conversation.

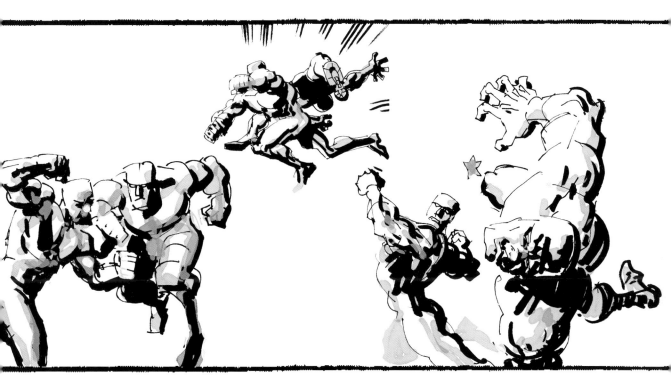

Lose Your Balance

Think about where the weight is resting on your character at all times. It helps to imagine gravity as a vertical line—with the character's balance determined by how evenly distributed the character's body is on either side of the line. Characters that are off balance appear to be in motion. Characters that are balanced seem to be standing still.

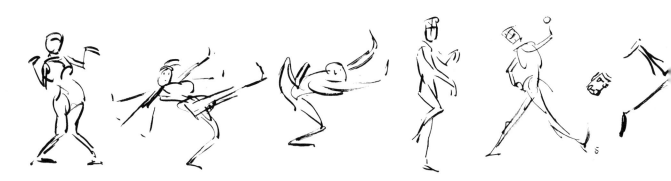

Stand Out from the Crowd

I'll tell you a secret. Comic books weren't really my favorite thing when I was starting out. I preferred animated cartoons. I initially chose comics as a profession for two reasons: First and foremost, animated cartoons were really bad when I was a kid. I loved watching older stuff like *Tom and Jerry* and *Bugs Bunny* and the Disney character Goofy, but even a three-year-old kid could tell that the more recent cartoons weren't nearly as good.

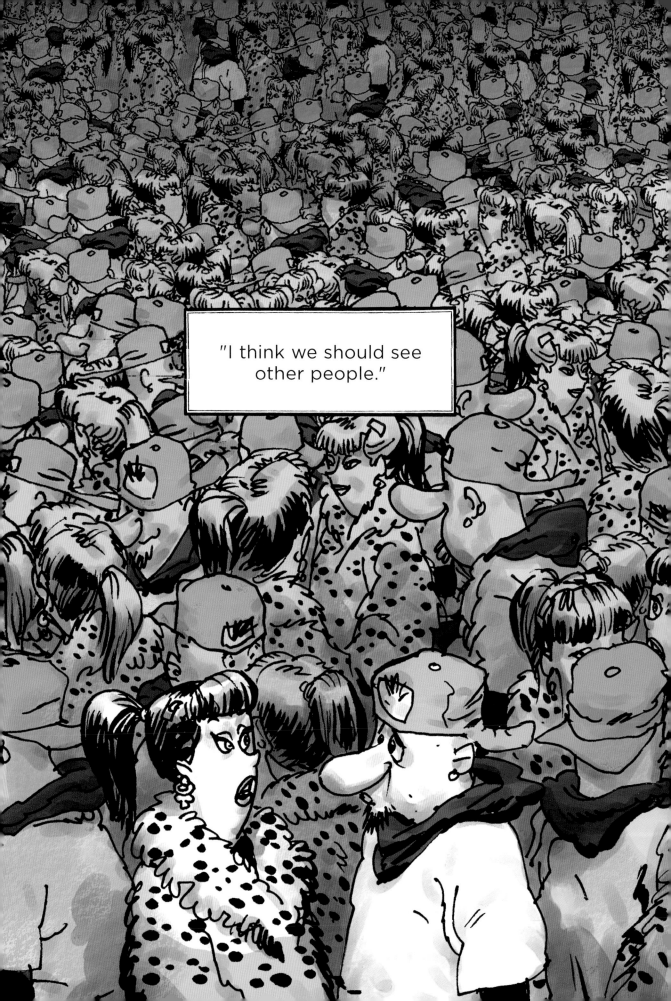

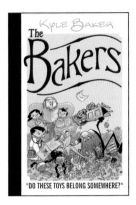
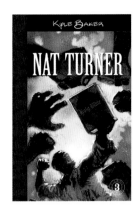

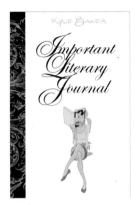
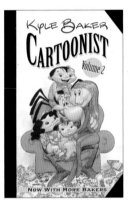
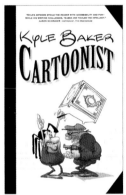

he thought of wasting my dreams on garbage like the TV cartoons of the 1970s and '80s was—and still is—repugnant to me. Most of the people making animation today grew up loving the bad cartoons of those eras, and the results speak for themselves. If you work for one of the factories that puts out bad TV cartoons, you're never going to be challenged to become a better cartoonist; in fact, it's been my experience that creativity is actively suppressed and discouraged at the bigger cartoon factories.

Second, I wanted to be the best cartoonist possible. Because I learn by doing, I needed to be free to try different styles and ideas to create something new that worked. So I chose comics as a profession. I had noticed that while Disney artists were all forced to draw in exactly the same style, the artists who draw superhero comic books were allowed to deviate from the "model sheet." Spider-Man looks different depending on whether he was drawn by John Romita or Steve Ditko. But it would be impossible to say who drew a particular image of Disney's Winnie-the-Pooh. They all look the same.

Difference was key. I wanted to work where I could be noticed—where being different and creative would be an asset rather than a liability.

Most animators and cartoonists just imitate the style of the most popular artist of the day. What a brilliant idea! Now you only have to compete with the two hundred other guys who had the same brainstorm! If two hundred other guys are doing exactly the same thing you do, you have no leverage.

That's why, whatever the currently popular style is, I deliberately move in the opposite direction. When photorealist comics were in vogue, I made my drawings more abstract

and unrealistic. When critics complained that my work was "too cartoony," I made it even cartoonier—and titled my next book *Kyle Baker, Cartoonist* just to make my point clear.

Does that sound crazy? Well, it got people's attention. People were talking about me. Getting noticed is the most important thing. If nobody notices you, you'll end up like the hundreds of other competent yet anonymous cartoonists in the world.

Think of this: Comic book covers usually try to compete for attention on the newsstand by using bright colors. On a rack with two hundred brightly colored comic books, what effect would an all-white cover have? Do you think it might catch your attention first?

When art buyers want a realist artist, there are thousands to choose from. But when editors and art directors are looking for a Kyle Baker cartoon, there's only one place they can go. They pay for the benefit of using my name as a selling tool. When I was asked to be guest art director on the *Class of 3000* TV show, I was given only one instruction: They told me to draw it in my own style, redesigning the characters and scenery in my own way. They even tried to animate it in my style.

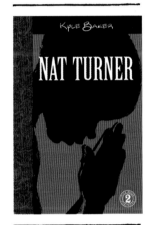

When I started my own comic book publishing company, I knew it would be futile to try to launch yet another costumed superhero. How could I compete with Spider-Man and Batman? Instead, I chose to do the kinds of comic books that nobody else was currently doing, but that I thought there'd be a market for. Like a comic-book biography of Nat Turner, the African American freedom fighter. (The cover is shown.) I specifically chose Nat Turner because his story was less well documented than those of other famous people from that era. The book has gone through multiple printings and continues to sell well because it caught people's attention. A new *textbook* about Nat Turner wouldn't have made any impact, but a *comic book* about a major historical figure was a unique gimmick at the time. Comic books are currently enjoying renewed popularity among young people, and educators see books like mine as a way to interest students in learning. Now my book is in public libraries and schools everywhere—a book with almost no text! You know how many people told me that the lack of text would be a drawback?

That's why you don't do the same thing everyone else does.

I want to add something, though: It's not enough to be different. Many unsuccessful people are "different." You also need to offer customers a unique benefit. People need to know what, specifically, they'll be getting if they buy your product. This book, for example, promises to teach cartooning skills that aren't found in the hundreds of other very good art instruction books available today.

Other books I've written offer laughs and an enjoyable time. People read them to feel good. My action-adventure stories, on the other hand, make readers feels excited and scared. They buy the book to feel thrilled, and I give them what they paid for. On the book's front cover, I always make it clear what the benefits I'm offering are, as the examples on these pages show. Then I make sure the contents deliver on that promise.

Keep It Simple

I have two priorities in mind when designing a cartoon: emotion and clarity. What is the emotion I'm trying to evoke in the viewer? If I'm trying to get laughs, I want the pictures to look funny. And clarity is just as important as emotion. What will make it easy for viewers to interpret the cartoon quickly and consistently?

When watching animation, viewers may have less than a second to interpret an image before it is gone and replaced by a different image. So each image must be crystal clear. The more information you can fit into that image, the better.

Information can be conveyed in many ways—camera angle, color, drawing technique, and so on.

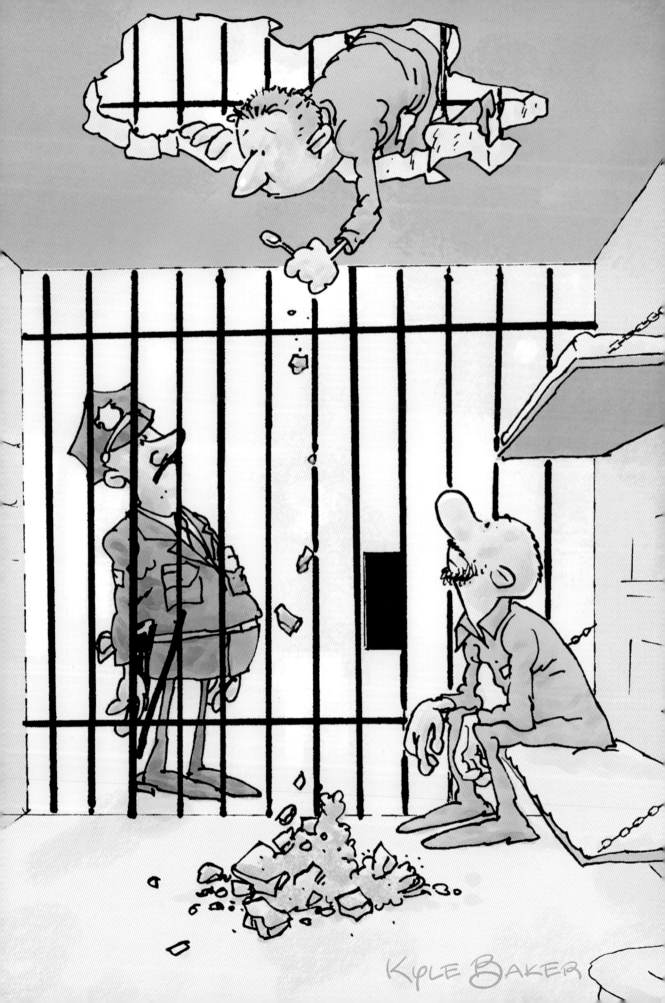

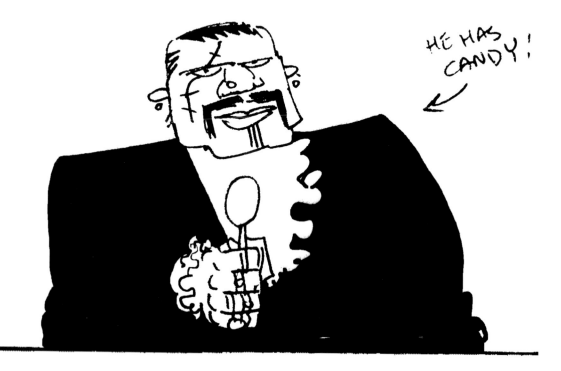

Designing Characters

The same is true with character design. Keep it simple, but get as much information into the image as possible. For example, . . . meet my adorable new cartoon character. His name is Squid. He wants to be your friend and hang out with you. He wants you to follow him somewhere—*alone*. Go on. He's cool.

What's that? You don't think you should follow him?

Why not? He has a gift for you! See him holding it? He's friendly! Look: He's smiling!

Why do you think he's dangerous? I'm sure he's a sensitive fellow. He's wearing a frilly shirt and lots of jewelry. Doesn't that prove what a classy guy he must be? Just take the lollipop!

My point is this: *Cartoon characters look like what they really are.* Everything about Squid tells you something about him. Even his name. Even his Fu Manchu mustache and the way his hair is cut. The scar. The large build. The sinister eyes.

The eyes are where the characters live. Not the smile, not the lollipop. The eyes.

Of these three, which character would make the best villain? Why?

Would this be a good design for a superhero? What type of person do you think she is? Do you think she plays any sports? Maybe she's a Navy SEAL!

Remember to offer dogs your hand so they know you're friendly. Do you think this doggy's friendly?

This is Voltrax the Dominator. Do you think he might be a rural Kentucky schoolteacher?

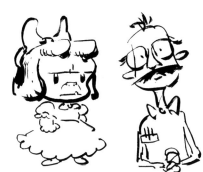

Between this little girl and her daddy, who do you think is in charge?

These two characters would probably make good leading characters. There's something about boring designs that makes a character sympathetic.

What people wear says a lot about them.

How they act says a lot, too.

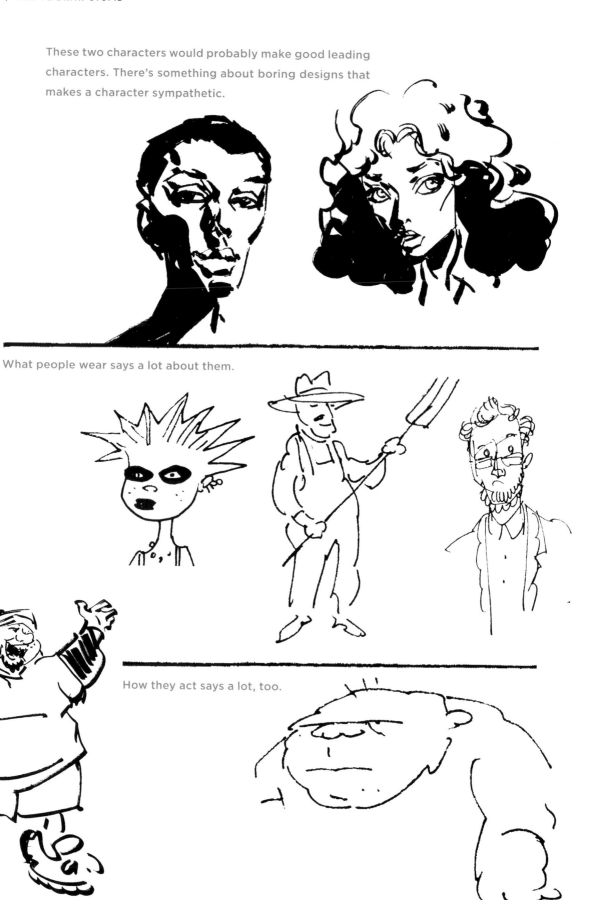

Cartoon characters are what they look like!

"I'm a legitimate businessman, your honor."

"Your daughter home, Mister? I'm her prom date!"

"Fun is my middle name."

"I'm positive that once I calibrate the proton fusion generator, my time machine will function."

"Food."

Clichés

Here are two more guys who look like what they are.

Clichés have the virtue of being easily understood, but the liability of being . . . clichés. The reason you see so many cartoons of people marooned on desert islands, or arriving at the Pearly Gates, or lying on the psychiatrist's couch is that you don't have to explain the backstory. It's fun, though, to try to find a fresh spin on an overused premise.

Different characters look different from each other. Man, do I hate war stories. And I do a lot of them. It's hard to differentiate the characters when they're all of the same age, gender, and race and they all have the same haircut and uniform! What you lose in character, though, you can hopefully make up for in explosions and bloodshed.

A Four-Year-Old Could Draw It!

A good cartoon character should be easy for everybody to draw. Even people who can barely hold a pen can draw identifiable versions of Bart Simpson or Batman. Any four-year-old can draw SpongeBob SquarePants, and that's important.

One way to simplify is to eliminate detail. Here, is a cartoon of me and my little son, Isaac. Now, in real life I have more than four hairs sticking out of my head, and I have five fingers on each hand. But those four hairs make it easy to identify and recognize my cartoon self. And the reason so many of my characters have only three fingers is that it doesn't matter how many fingers they have. And it's two fingers less to draw a thousand times.

Another way to simplify is to exaggerate contrasts. See how my fat torso contrasts with my skinny legs, which again contrast with my big feet.

Little Isaac has a wide head and a tall body. I have a tall head and a wide body.

Simplify. Make sure your drawing is easy and fun to imitate. Then invite people to imitate it.

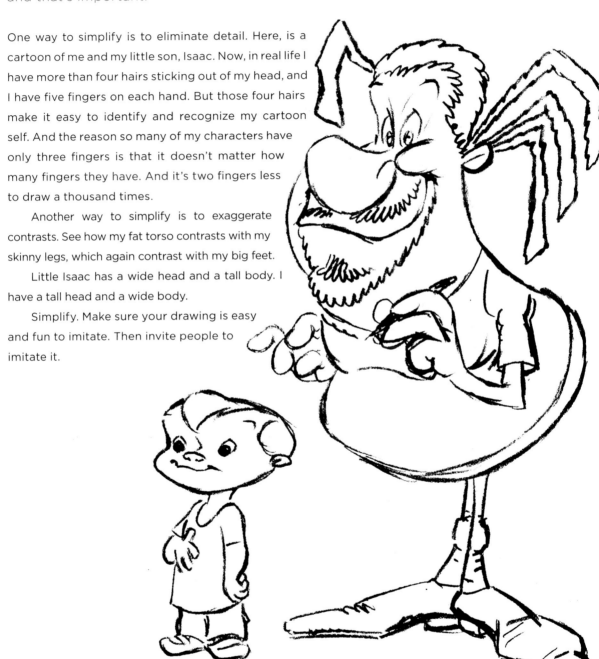

Here are some drawings kids gave me.

Can you tell who they are? Of course you can! And that means the cartoons they're copying are good designs!

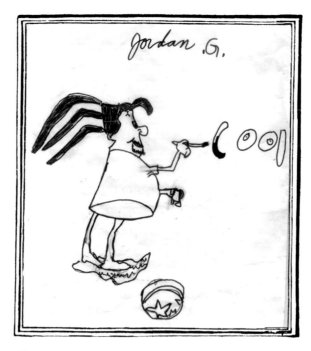

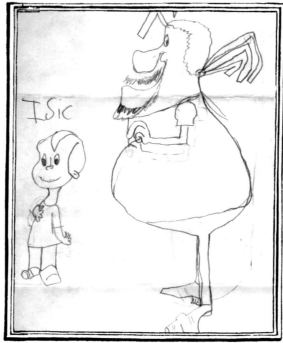

Baby Jackie's most identifiable traits are her chubby cheeks, her big belly, and her hairstyle. See how this kid's drawing gets everything right? See the contrasts? Thin hair, fat head, thin shoulders (with no neck), fat belly, tiny feet? Even a four-year-old kid can do it!

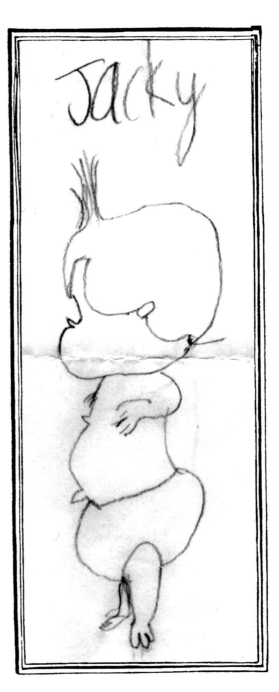

Simplify to Communicate

The gag on the facing page is about the contrast between appearance and internal character. Everything about the top and center drawings leads you to believe that this is a man of wealth and sophistication—his body language, the suspenders, the tie, the cologne, the limo, the chic girlfriend. The last drawing surprises us with what he's really like.

Look at the photographers in the center panel. They're mostly obscured by camera flashes. We see no faces, no clothing details. That's because these characters aren't important to the story. The fact that there are a lot photographers on the scene is the only information necessary to the story. If I were to add details like beards or interesting clothing details, it would be distracting. Viewers wouldn't know where to look, and they might miss other, more important details. As it stands, the reader will focus on the man's big black shape and the light silhouette of his girlfriend, which pops out against the dark limo in the background.

When simplifying things, I leave nothing in the art that is not story information of some sort. What little we see of the boxer's home implies he has taste. The second and third drawings tell a lot while showing very little.

In the last drawing, it's completely obvious where we are, even though all we really see are two ropes and a floor. The costumes help. I often try to make the design of the last panel in a series less interesting, because I don't want readers to accidentally look at the punch line first (which in this case is a literal punch).

Silhouette the action. Notice how, in the cartoon about the boxer, the "camera"—that is, the artist's point of view—always seems to be at a 90-degree angle to the line of action. That's the clearest way to show action.

Streamline designs for clarity and to enable easy repetition. Simplifying for the sake of easy repetition is important, because you may sometimes have to draw the same character hundreds or thousands of times. In just one book, I may have hundreds of drawings of the same character, and in animation, a character might have to be drawn thousands of times.

Believe me, if your character is wearing a plaid shirt and you have to draw that plaid ten thousand times, you'll wish you'd dressed him in a nice solid color instead. If you choose a plaid, that plaid had better be important to the story.

Characters with freckles make me cringe. Freckles are not a character trait. They probably aren't necessary to the story, either. On the other hand, if a character wears a flashy polka-dotted jacket because he's a flamboyant, loud guy, that's different. Losing the jacket would weaken the character and make the story harder to understand.

In other words, every element of your cartoon should communicate. If it doesn't aid communication, it's a distraction and should be removed.

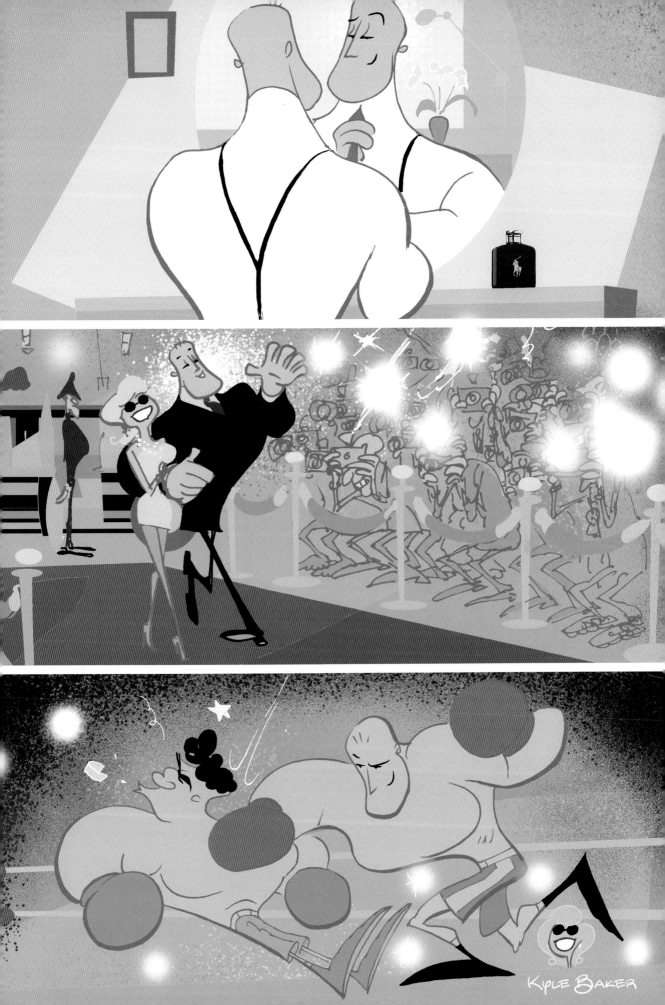

Kyle Baker

Use Reference Material

People are always telling me that hands are difficult to draw. That's ridiculous. If you're drawing, then you probably have at least one hand, so take a minute and *look at it*. Now, draw it.

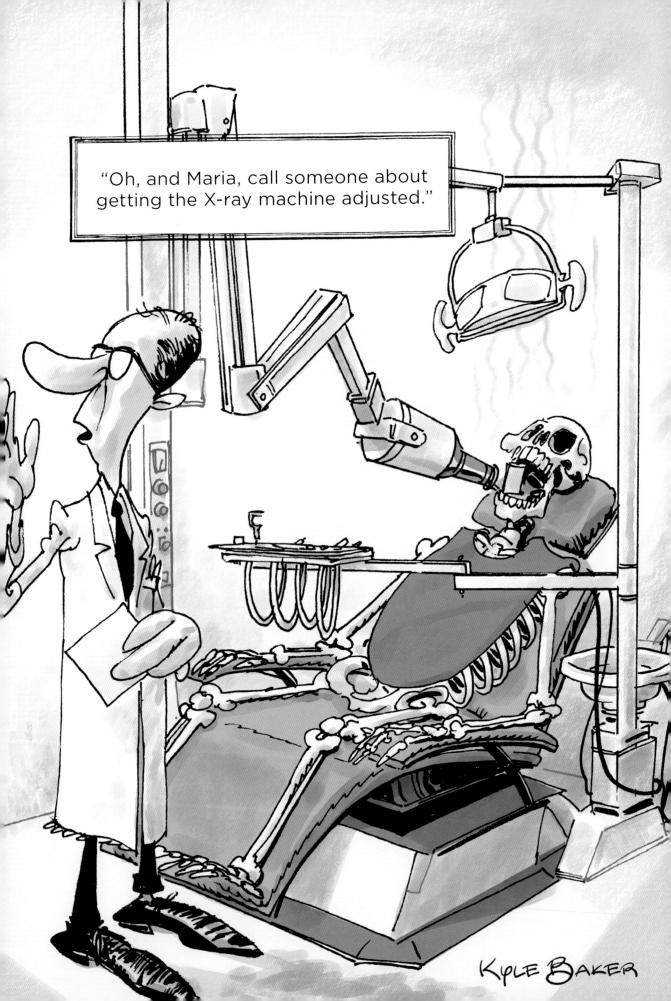

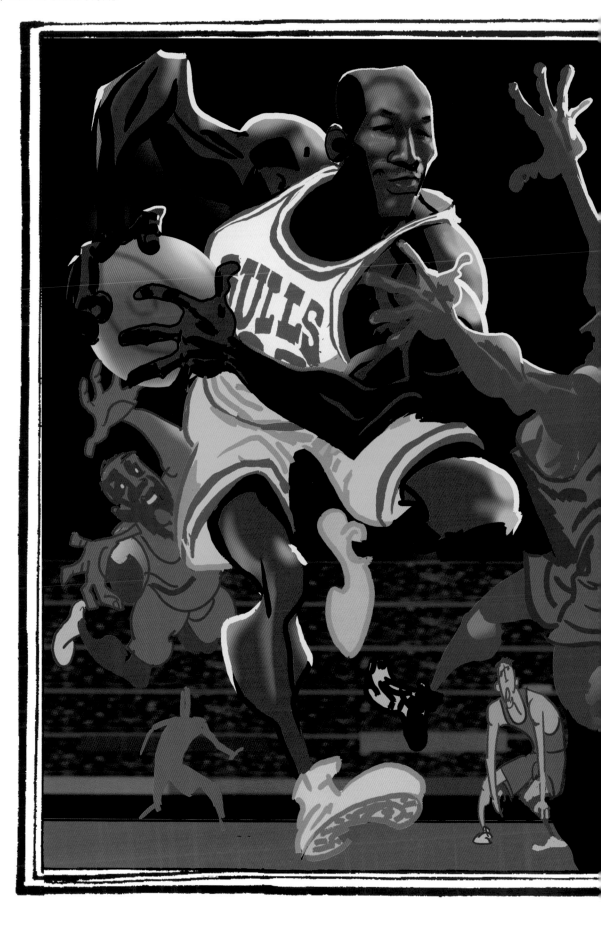

If I want to figure out how to draw a character in a certain pose, I do the pose myself in front of a mirror and look at it. If I want to draw a phone, computer, or washing machine, I use one in my home as a model, and draw it.

For the viewer to get the gag in the X-ray cartoon, it was important that the setting be immediately recognizable as a dentist's office. On the Internet, I found photographs that I studied so that I could draw the chair and machines properly.

For the magazine caricature here, I looked at lots of photos of Michael Jordan. I also researched details of the Chicago Bulls uniform and the basketball court. Although the image is very distorted and unrealistic, the sports celebrity is immediately identifiable.

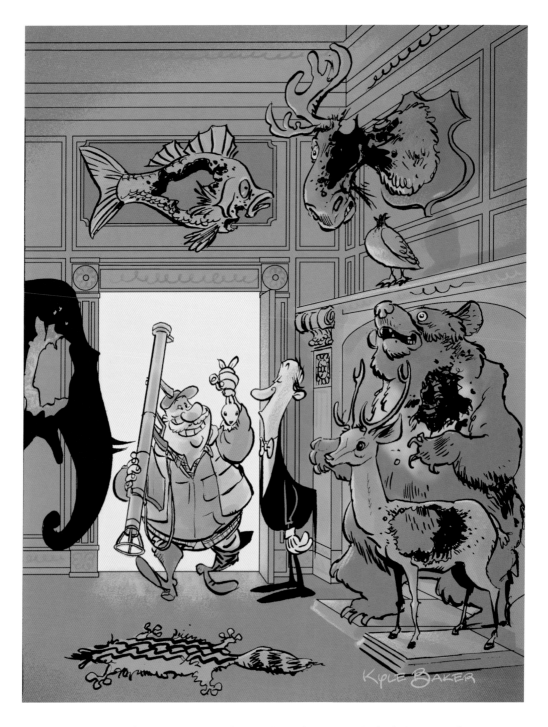

Both the cartoon of the hunter and the Noah's ark cartoon include images of numerous animal species, which had to be researched before I began to draw. The bazooka, the hunter's and butler's outfits, and the ark were also all done with the aid of reference pictures.

Don't try to fake stuff, or try to guess what something looks like, or work from memory. That's not only lazy, but lots of people looking at your drawing won't know what it's supposed to be.

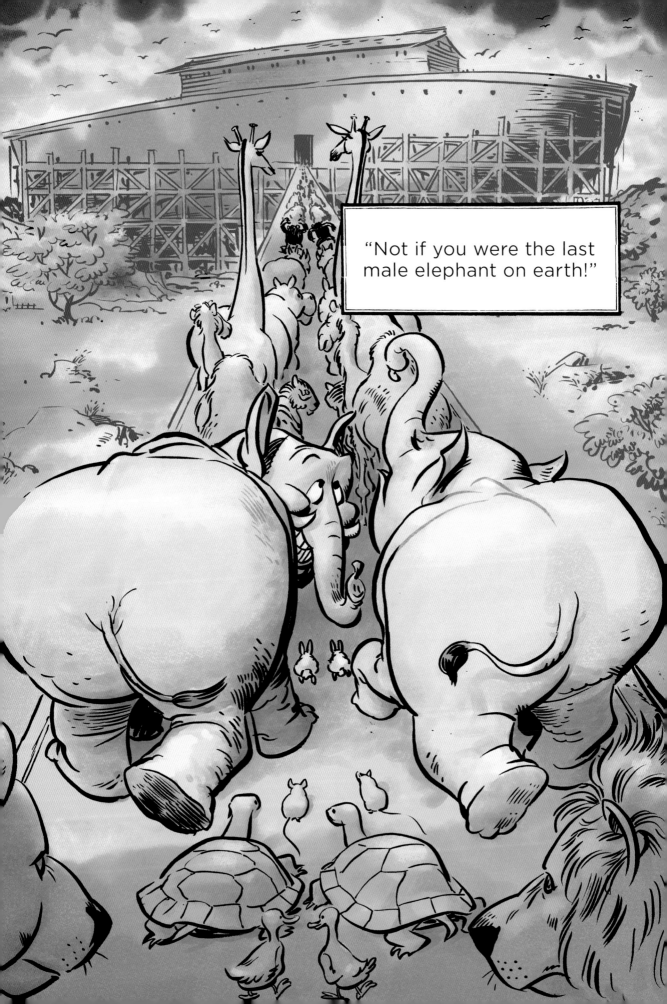

Make It *Funny*

Believe it or not, people don't look at cartoons for the dialogue. Or for great art. Better dialogue and better art are more easily found elsewhere. The most important thing about a cartoon is the funny pictures.

The cartoon at the right contains the bare minimum necessary to tell the story. But look at how much we can see: What time of day is it? Which room of the house is this? How old is the character? How tall? What's going to happen next? You know the answers to all these questions instantly. There's no confusion. The cartoon has everything you need to know for the story to work. Simplicity results in immediate communication.

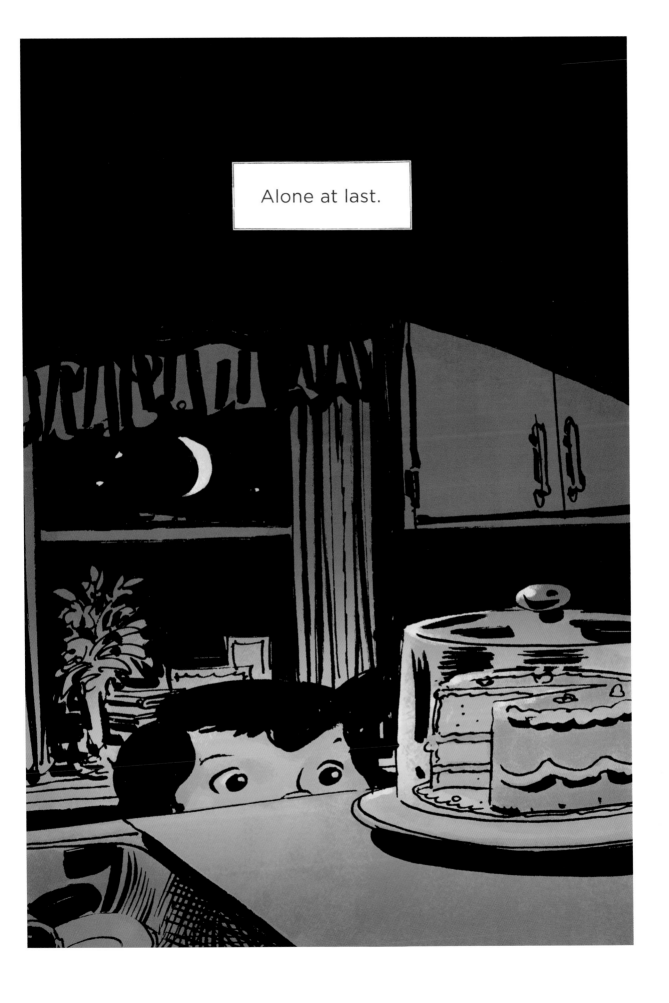

"Get out of the way!"

S o how do you make a picture funny? The drawing above has a number of funny elements: The costumes are funny. The situation is funny. The kids look funny.

The characters are doing funny things **IN CONFLICT** and **IN CHARACTER**. They're not conscious of the effect they're having. They aren't telling jokes or performing to amuse you. They don't *know* they're funny.

The three characters in the cartoon above all have different and distinct personalities, which are apparent in their costumes, body language, and facial expressions. The boy, Isaac, is clearly on a different wavelength from his siblings. The fact that he keeps drinking his juice box underscores this. Baby Jackie, however, seems immersed in her big sister's fantasy.

This cartoon doesn't need any "setting up" or "backstory." The story here is obvious, even to someone who's never seen these characters before, because, as I said before, *cartoon characters are what they look like*. (By the way, notice how, here again, all the characters are clearly silhouetted. Clarity is essential!)

You've Got to *Love* Humor

I love humor. Humor is measurable: If someone laughs, it's funny. If nobody laughs, it's not funny. Big laughs means very funny; small laughs, not so funny (but still funny).

FOCUS GROUP

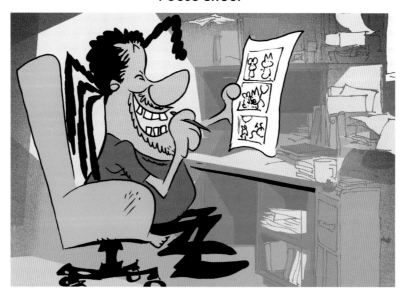

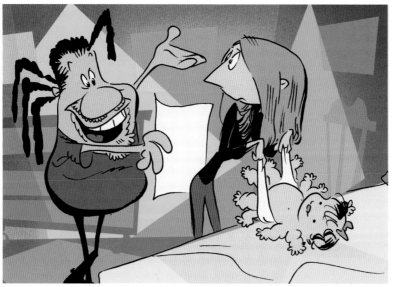

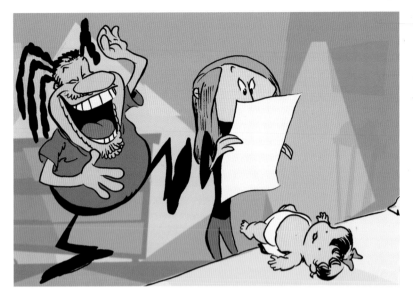

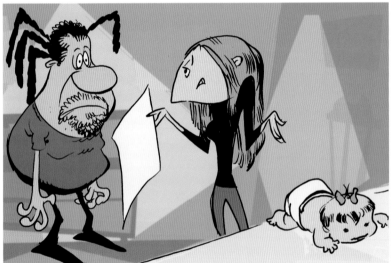

Laughter is involuntary. It's not like booing. You can fake a boo. Or applause. You might applaud at the end of a rotten show. But if humor's not funny, you won't laugh. A fake laugh always sounds fake.

People can look at an artsy drama and not be able to tell whether it's good or bad. So they applaud. Whether a drama is any good is open to debate. I think some award-winning dramas are lousy, but who can say for sure?

If a sad movie makes me feel awful, is it a good movie or a bad movie? Was the knife fight too intense? Did the wrong character die? Was the story supposed to be impenetrable? If a horror story is horrible, is that good?

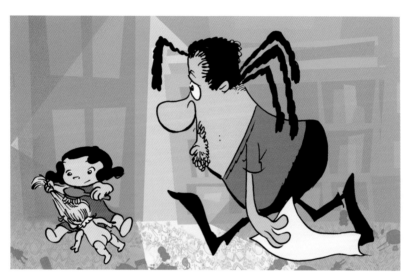

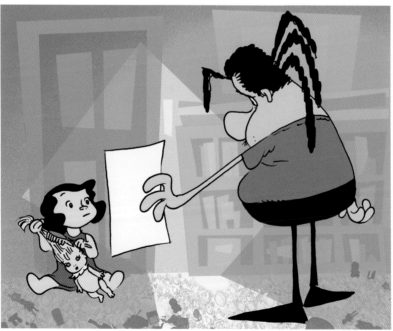

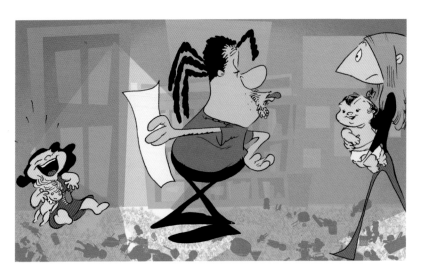

You can't argue about funny, though. If people laugh, it's funny. No laugh, not funny. Humor is measurable, and anything measurable can be tracked. You can make something funnier by adding laughs and cutting the parts that aren't funny.

Picture First, Dialogue Later

I write gags the same way many of my favorite cartoonists do: First, I think of the picture, then I write the text (if any) afterward. That way, I make sure the images are compelling. I make sure I can pack so much information into a single image that the text is nearly superfluous.

Another reason I put most of the story into the art instead of the text is that successful cartoons cross language and cultural barriers. My cartoons have fans around the world, because you don't necessarily have to read English to understand them. I've been invited to many different countries—including Argentina, Spain, and France—where I've signed thousands of autographs for people I can't communicate with in words.

During my early days as a Marvel Comics artist, the editor-in-chief was always reminding us, "The audience for Marvel Comics is kids. You have to make the story clear in the pictures, because half your audience can't read yet!" Then he'd give us comics drawn by Jack Kirby, who designed almost all of the original Marvel Comics.

Kirby's style was what made Marvel's comic books such a hit in the 1960s. He would work with a writer using the following method: *First,* he drew the book, *then* the writer added the dialogue. I have a Jack Kirby comic book I bought on an overseas trip to look at on the plane ride home. I had no trouble understanding and enjoying the book, even though it was in Portuguese, which I can't read.

Walt Disney used to insist that his films tell the story visually, so that dialogue wasn't really needed. Most people can't tell what Donald Duck is saying anyway, but it's always clear what he wants, what the story is, and what his personality is. *Bambi,* one of Disney's best feature films, has barely a thousand words of dialogue. Disney had his story writers create the artwork first and then work on the dialogue afterward.

Peanuts creator Charles Schulz also created the artwork first. He'd think of a funny image—like a dog sleeping on top of a doghouse—and then figure out the story of how the dog got up there.

Frank Miller, the famous cartoonist and movie director—the *Sin City* and *300* comics are among his many credits—always does the layout and design before creating the dialogue. Will Eisner, creator of the American graphic novel, worked the same way. So I figure that if this method of working has been effective for the most successful cartoonists of all time, it might be worth imitating.

When I create a graphic novel, I do the artwork first. Then I lay it out, designing the pages on a computer. Only after I'm convinced that the book works visually do I add the text, as a counterpoint and supplement to the visuals.

Watch People Draw

I watch people draw. I learn things that way. I watched my dad draw. He used to make up cartoons for our bedtime stories.

When I was an intern at Marvel Comics, I spent my free time watching Jack Abel draw. Jack—who inked *Superman* for DC and, later on, *The Incredible Hulk* for Marvel—was nice enough to not chase me away.

I once saw Bill Sienkiewicz—the illustrator of graphic novels like *Voodoo Child: The Illustrated Legend of Jimi Hendrix, Stray Toasters,* and *Elektra: Assassin*—draw without picking up his pen from the paper. I don't know if he still does that. I try it sometimes.

I used to watch a video of Charles Schulz drawing the *Peanuts* strip. I practiced moving my hand the same way to get that marvelous wiggly line. Years later, I read in a biography of Schulz that his hands shook involuntarily because of a heart condition. Talk about turning lemons into lemonade!

Start with Stick Figures

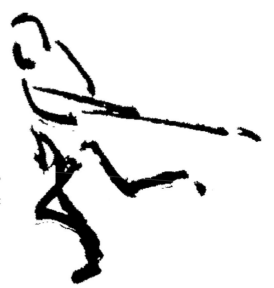

I often like to start with stick figures. I find it's the best way to create strong, expressive poses. If the story isn't clear in a stick figure, the pose must be weak.

See how these two drawings tell a story? There's no costume, no facial expression, yet you know exactly what this person is doing.

How about these two? Are they having a friendly conversation?

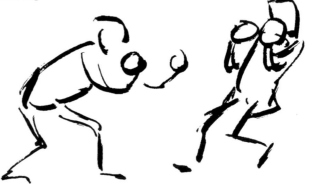

Look! Two different runs! Their different attitudes tell a story, don't they? These guys aren't racing, they're chasing!

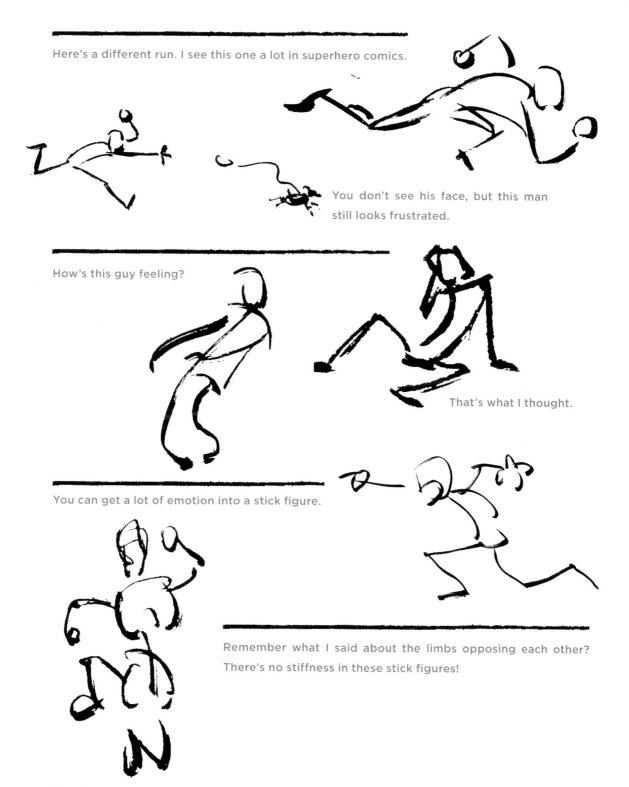

Here's a different run. I see this one a lot in superhero comics.

You don't see his face, but this man still looks frustrated.

How's this guy feeling?

That's what I thought.

You can get a lot of emotion into a stick figure.

Remember what I said about the limbs opposing each other? There's no stiffness in these stick figures!

Now it's your turn to try. Draw a stick figure, and show it to someone. Are you able to communicate a character's thoughts and emotions clearly through a stick figure? If you can't, you need to stop right now and learn how to do this. Everything else hangs on this.

But you *can* do it. It's a freakin' *stick figure,* for heaven's sake!

Show Your Characters *Thinking*

Character is everything. Even more than what they look like, characters are defined by what they do. And, as I mentioned before, we're looking for characters *in conflict* and *in character*.

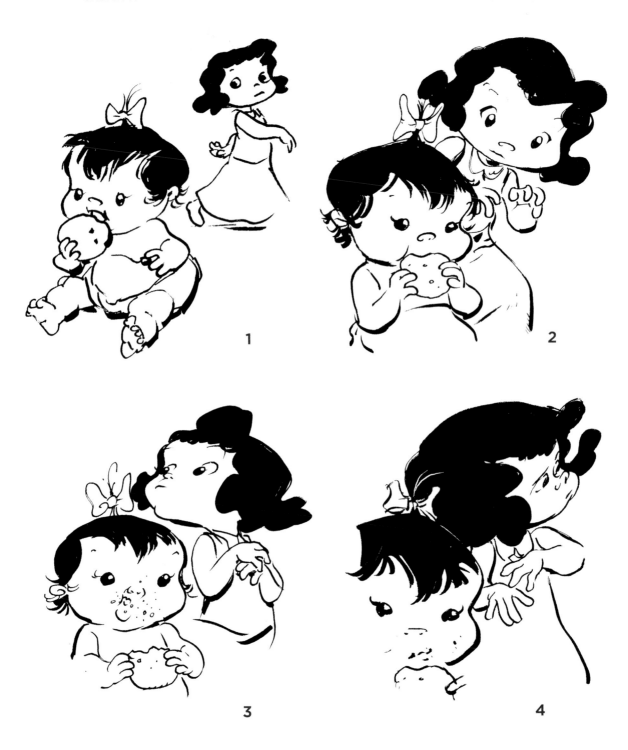

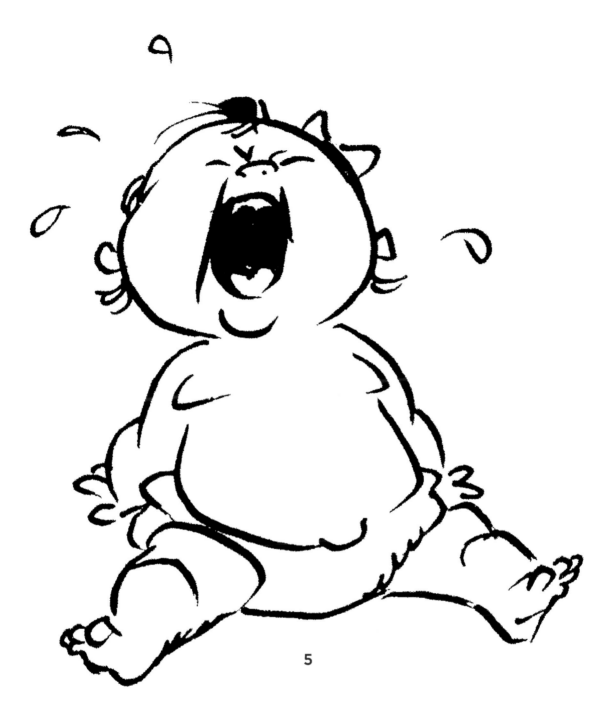

5

You can add definition to a character by showing the character thinking. Notice how you can tell what the older girl in the cartoon is thinking from drawing to drawing. What she's thinking clearly *changes* from frame to frame, as well. What's she thinking in the first drawing? What about in the second? See how her focus changes from the second to the third drawing? And what has happened between the fourth drawing and the last? It's easy to figure out, because the big sister's thought process is so clearly shown—and because the baby is reacting in character.

Show Your Characters' Attitudes

In these frames, Dad's personality is apparent—and in marked contrast to the kids' attitudes. Remember what I said earlier about balance? The kids seem to be in motion because they're off balance. In the first frame, the boy is vertical, but his feet aren't grounded. As we go from frame to frame, the characters follow an invisible arc defining the path of motion. The most important thing here is the action—making the direction of motion clear. And the kids react in character. (As does the wife, in the last frame.) I'll say it one more time: Good cartoons show characters in conflict and in character. They clearly display the characters' attitudes.

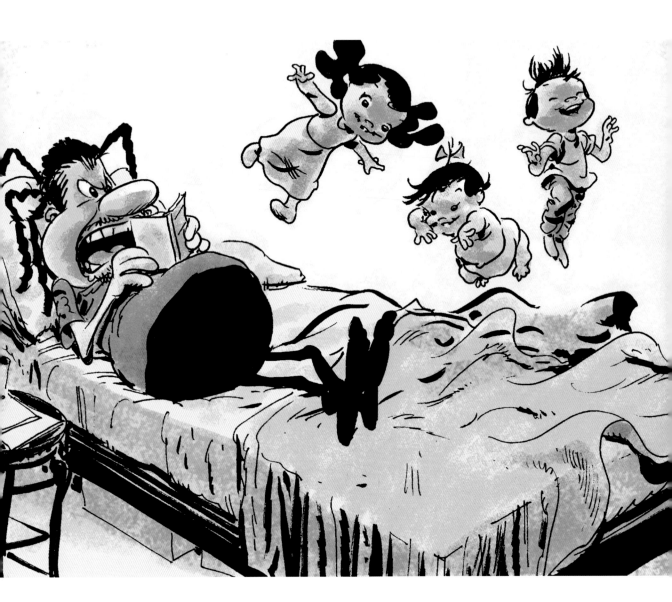

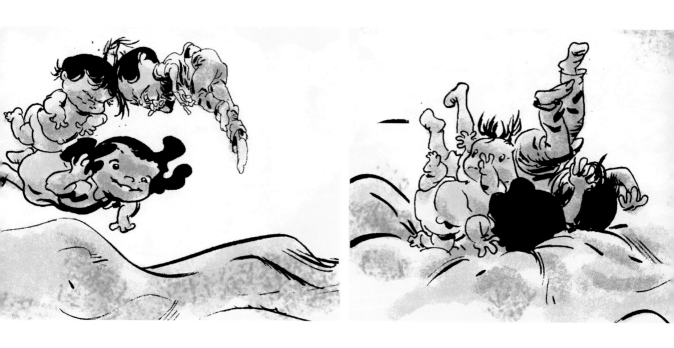

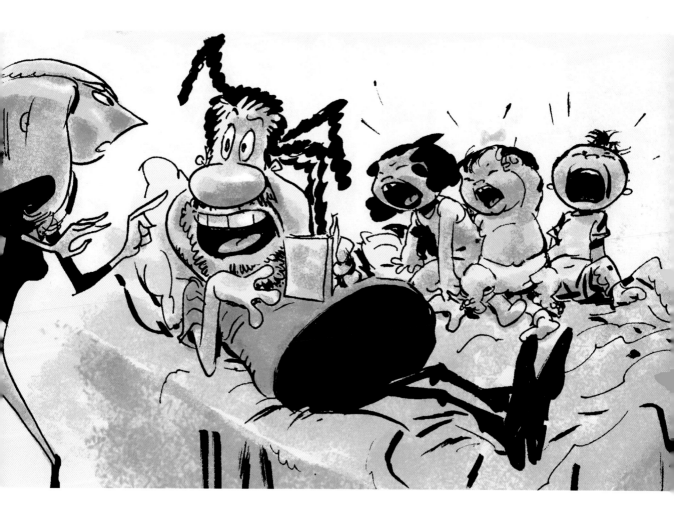

10

Don't Make Jokes

I used to have a sign over the door of my studio: "Jokes Aren't Funny." Sure, that's overstating the case. Many cartoons have jokes. I write jokes myself. Stand-up comedians and newspaper cartoonists entertain millions—and sometimes make good money—with jokes. I love jokes. But that's not what this book is about. This book is about showing you how to generate emotional responses that are consistent across a broad spectrum of people.

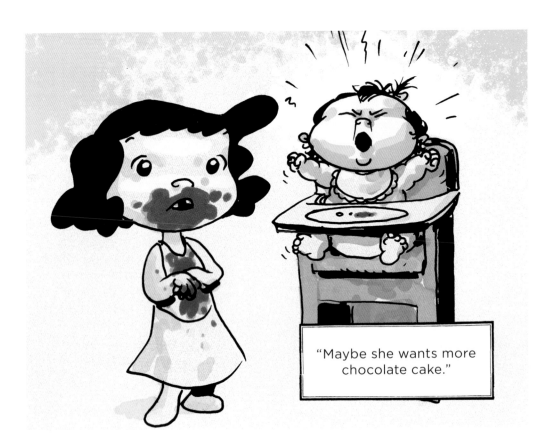

"Maybe she wants more chocolate cake."

I f your cartoon is to be funny, it must be funny to *everybody* who sees it. If half the people say, "I don't get it," your gag has failed.

And that's the problem with jokes. Jokes rely on language, and language is subject to too many variables to produce consistent, predictable effects across a broad spectrum of people. For instance, sometimes the same word will mean different things to different people. *Gay* might mean "happy" to some people. *Bad* might mean "good."

And a joke's success might depend on readers having the same set of cultural references. If I call a character "Honest Abe," would a Croatian get the reference?

By the way, the same thing's true of scary stories. To be truly scary, a story needs to scare *everybody*. If I'm scared of kittens and I make a monster movie about kittens, only people like me will be scared.

Characters Are Funny

People respond to characters more than to dialogue. Thinking back on the *Peanuts* strip, I honestly can't remember a single joke Snoopy told, and I love Snoopy. I'm sitting here trying to remember whether he ever told a joke, and I can't remember a single one. I can tell you about all the funny things he did, though. How he pretended his doghouse was a plane, how he played Little League, how he teased cats and typed bad stories and loved to dance . . .

My five-year-old daughter asked me, "Daddy, can I have a puppy and some candy?" I gave her a look, and she quickly said, "Just candy would be OK." That's not really a joke, but it's funny because it's in character. And that's what I want you to do: Aim for honest emotional reactions *in character.* You are emotionally attached to your favorite characters. You care what happens to them. We fall in love with characters, not jokes.

When I make a cartoon, I focus on the characters, the situation, and the emotion. The purpose of entertainment is to manipulate emotion. We want to feel something. Action stories excite us. Tragedies make us cry. Horror stories scare us. Comedies make us happy. At the end of the day, it's the viewer's *emotional state* we're trying to affect. And since I assume that my audience wants to feel good 99 percent of the time, I focus on producing that effect.

In trying to generate emotional response, we cartoonists have tools at our disposal that are much more effective than mere language. We can *surprise* viewers. Point at them. Confuse them. Interact with them. We can use perspective, unusual points of view, lighting, color!

What it all comes down to is this: In cartoons, jokes aren't funny. Pictures are funny.

"Daddy, can I have a puppy and some candy?"

"Just candy would be OK."

Hitting Is Funny

Yes, hitting is funny. It always gets the biggest laughs in an animated movie, especially from the kids in the audience. Make sure your cartoon characters get hit a lot.

A cartoon hit has three stages, and each stage provides you with an opportunity to get a laugh.

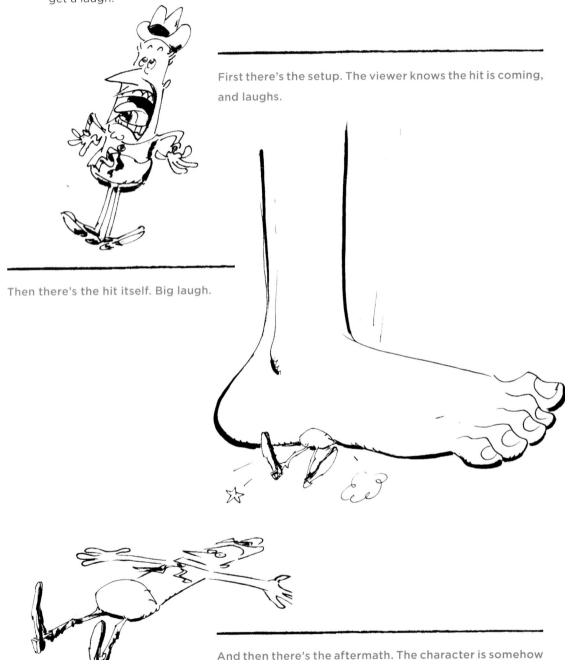

First there's the setup. The viewer knows the hit is coming, and laughs.

Then there's the hit itself. Big laugh.

And then there's the aftermath. The character is somehow maimed or defaced. Third laugh. Make sure you get *all three* laughs.

Precious Memories

By the way, "hitting" doesn't have to be literal hitting. Notice how the sequence here follows the same pattern.

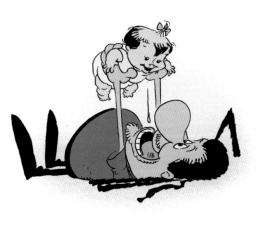

Antics Are Funny

Getting the illusion of movement into a still image is tough. Graceful movement follows a graceful arc. Funny movement is . . . well, it's funny.

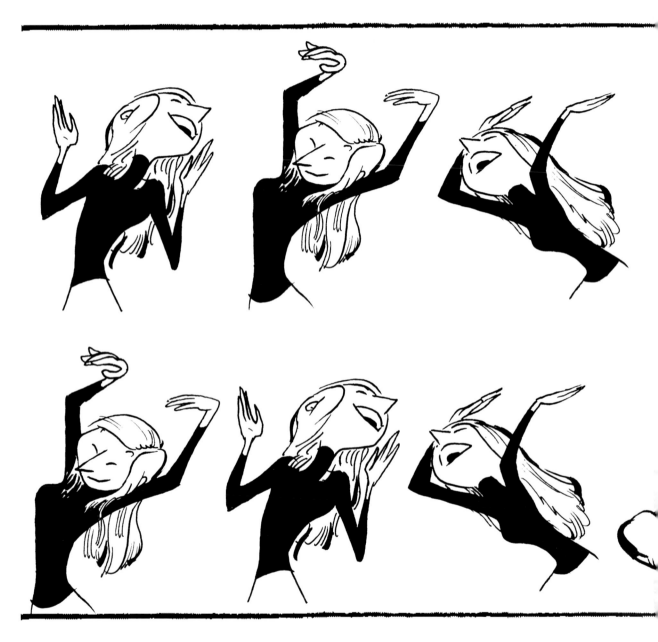

Antics are the moves that precede and anticipate a bigger move that follows. (The word *antic* is short for "anticipation.") The principle here is similar to that of the three stages of hitting. Let people know that you're going to do something, then do it. If you set up an expectation with an antic, though, you've got to surprise the viewer with an unexpected follow-through. That's what makes it funny.

Create movement on a comic book page through a series of still images. By combining the antic with those other principles for loosening up figures (body masses in opposition, alternating limbs), the illusion of movement is created when the drawings are read in sequence.

CHAPTER

11

Escape the Hand of Death!

There are two plagues that make cartoon acting dull. One is the blight of model sheets, which result in cartoon characters who have only six facial expressions and are never able to turn their heads, because the model sheet only shows front, side, and three-quarters views of the character. Model sheets are used so that studios can hire unskilled, nonunion cartoonists in Third World nations, paying them a pittance to imitate the drawings of skilled cartoonists who cost a lot more.

The other enemy of cartooning is what I call the Hand of Death.

As I've said, all good cartoonists do the art before they do the words. But television and movie cartoons are created backwards, with the words being written first. It has to be done this way. If you don't have lots of great dialogue in your cartoon, how are you going to get a star like Freddie Prinze Jr. to do the voice?

OK, so now you're a storyboard artist, and you're given a script or a recording of some actors reciting the dialogue: "Good heavens, Jimmy! If we don't deactivate that robot in ten minutes, the dimensional rift will become volatile!" Or maybe: "You did it! You found the seventh dragon amulet! Now we must return the power stones to Lord Mongor!"

You've drawn a close-up of your character saying this chunk of dialogue, but there's a problem: The recorded line of dialogue is roughly five seconds long. If the character doesn't move for five seconds, it stops looking animated. But how many poses can you create for the character to really *act out* the line?

So the lazy (or rushed) cartoonist buys precious screen seconds with this: the Hand of Death!

If you are a working cartoonist and you catch yourself doing this, you should kick your own butt. I mean, who *are* these guys? What are they saying? Answers: Nobody and nothing! Who actually does this when they talk? I've only seen politicians make this gesture, and they look phony when they do.

There's no excuse for this. First of all, if what the character is saying isn't totally boring, why not put some emotion into the drawing? And if what the character says is boring but is actually necessary to the story, why not cut away to a reaction shot, or a diagram, or a flashback, or something—anything!—else?

Also, who just stands around talking? People usually *do* something while they speak. So maybe your character can do something to hold the viewer's interest while he slogs through the torturous expository dialogue that the writer is convinced is so crucial to the story.

Or how about this?

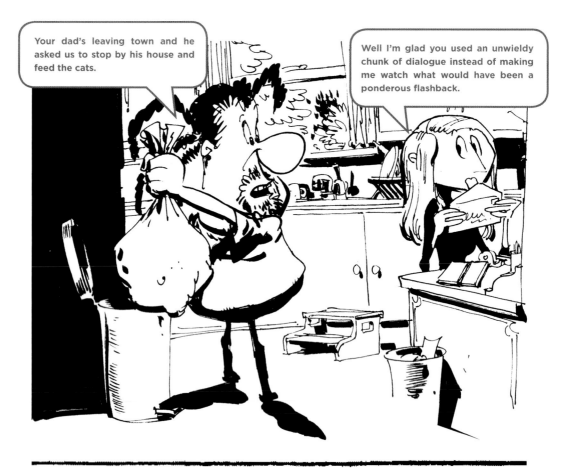

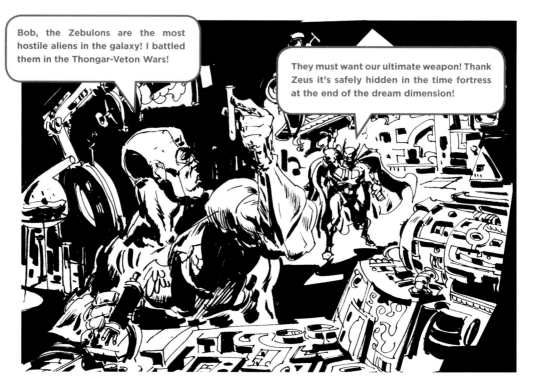

If the characters are disagreeing, have them move away from each other.

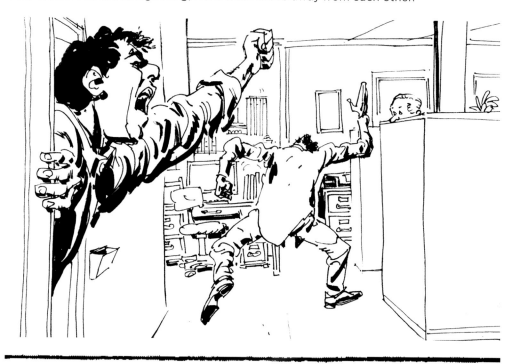

If they are friendly, they can pat one another on the back, so to speak.

Don't just stand there, characters! Do something with your hands! Tug at your collar! Build a house of playing cards! Anything beats just standing around with your hand raised as you go, "Blah blah blah blah blah." Anything's better than the Hand of Death!

CHAPTER

12

Be Iconic

All your favorite picture books have images that stick in your head after you've put the book away. I can think of my favorite Dr. Seuss drawings and see them in my mind right now. You need to get as many *iconic* images in your cartoons as possible—pictures that are so powerful that someone can see them out of context and want to see more. The book covers opposite all contain iconic images.

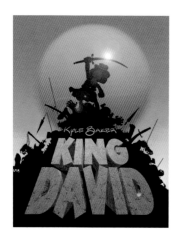

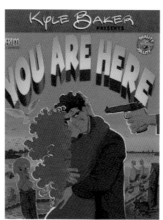

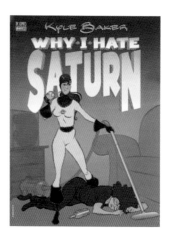

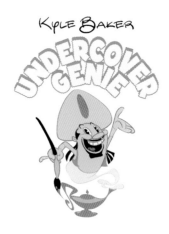

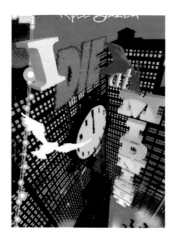

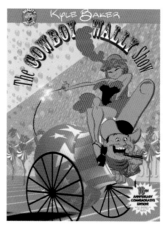

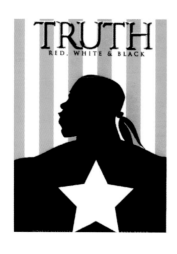

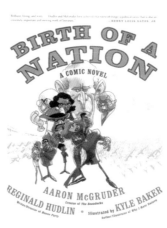

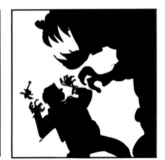

These series of panels provide examples of what's called the "subjective camera." You see the action—or much of it—from the characters' points of view. Remember: Your primary goal is to stimulate an emotional response in the viewer, and subjective camera technique serves the same purpose, visually, as a first-person narrator in a written text. The reader *becomes* the character and feels what the character feels.

Even if the drawings are sketchy, you are in the character's head. You see what he sees. You feel how he feels.

The technique follows a formula: First, show a close-up of the character. The next shot or shots are from the character's point of view; we see what they see. Then cut back to the character's face, and change the expression. The viewer feels what the character feels. I added the long shot at the end, below, to show the changed spatial relationships: The man is now on the floor, and the woman is standing over him. If I had just used the close-up of his face, a reader might think the man was still standing—maybe leaning against a wall.

Get Stupid!

Comic characters are stupid. That is because comedy is stupid. Only one of these mice is truly and undeniably stupid. Which is it?

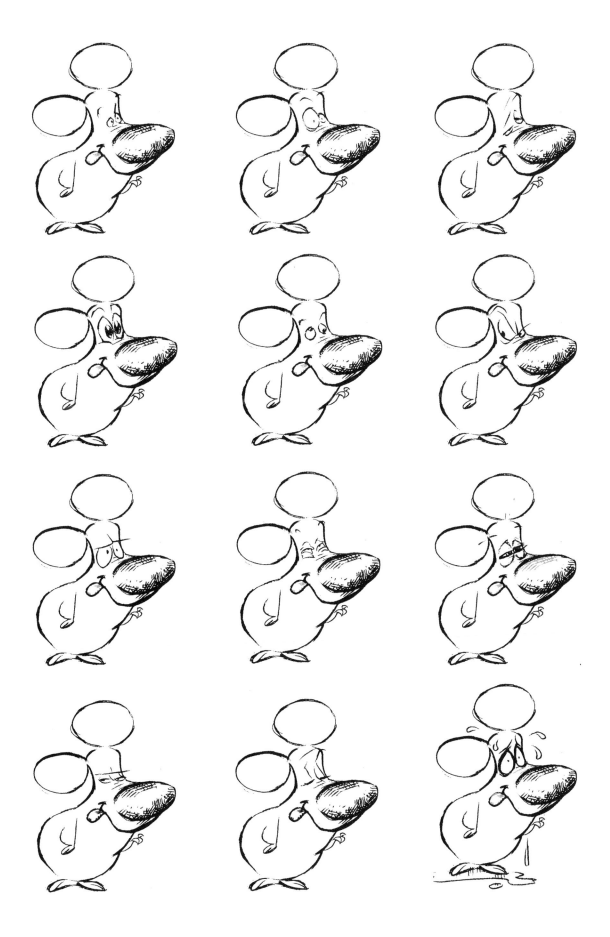

Smart people aren't funny. Smart people who try to be funny are called satirists. They should be avoided at all costs.

"Intellectual humor" is like health-food candy or nonalcoholic beer—a pointless waste of time created for people who don't know they're supposed to enjoy things.

You are not like that. You want to use your powers of comedy to make friends with normal people. To this end, your cartoons must be stupid.

Now I, a noted cartoonist, will teach you how to draw stupid people—or, to put it another way, to draw people stupid.

(And by the way, stupid people are safe to ridicule, because they always think you mean someone else.)

The Stupid Look

The crucial element in creating a stupid cartoon character is the stupid look. People should be able to see at a glance just how unintelligent your cartoon character is.

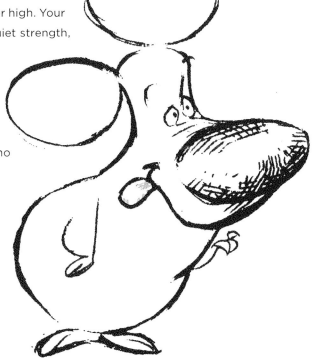

The eyes show what a character is thinking. It is important that your stupid character's eyes show that he is thinking *absolutely nothing.* A good stupid look is tricky to do right. Push it too far, and the character looks insane or high. Your goal is to achieve that perfect balance, that quiet strength, that elusive soap bubble of true stupidity.

I use a mirror.

Having the character drool, showing him with his tongue hanging out--these kinds of "props" can help, but as this stupid mouse (yeah, this is the one) shows, there's just no substitute for stupid eyes.

Look deep into those eyes. Feel their complete and utter stupidness. If you go back to the drawing of all the mice, on page 85, you'll see how subtle adjustments to the size and shape of the mouse's eyes change his entire personality, or character. But note that none of the other expressions convey idiocy as effectively as this first mouse's eyes.

The key to a good stupid expression is defocusing the eyes—just enough. Here, try it yourself. See if you can't capture the mouse's look of bottomless dunderheadedness.

Why So Stupid?

At this point, you, eager student that you are, may be wondering why it is essential for comic characters to be as stupid as possible. Well, it's because cartoons need hitting to be truly funny. A handsome heroic type or pretty girl being hit isn't funny—it's dramatic. A stupid fat guy falling down a flight of stairs is hilarious. But he has to be really dumb. A stupid skinny guy being hit is funny, too. A stupid fat guy hitting a stupid skinny guy is Beetle Bailey.

Some cartoonists, for whatever reason, are unable to draw blank stares. I draw blank stares whenever I tell my kids to pick up their toys. But I digress. If you can't draw facial expressions well but still want to be a cartoonist, you may use props to inform your audience of your character's exceptional witlessness. I've mentioned drooling and tongues hanging out. Stupid costumes can be great, too. But the greatest of all props is . . .

Buck Teeth

Buck teeth are a basic building block. A lot of cartoonists draw their stupid characters with buck teeth. This is because buck-toothed people are stupid. Just joking. The real reason is that unattractive people are funny.

Unattractive and stupid people are funny because they are genetically inferior, and it makes us feel good about ourselves to mock the less fortunate. Most people look like movie stars, and that's why it's good to laugh at physically unappealing people. I mean, if they aren't sick or something.

I feel we are approaching a dangerous area here. Clearly, there are certain parameters of morality and good taste that must not be exceeded, even for entertainment's sake. Some ethnic groups should not be ridiculed in cartoons. You can, however, make fun of non-English speakers (but only verbally, so they won't find out).

Crossed Eyes

Crossed eyes are the foundation upon which your buck-teeth building block rests. A lot of stupid cartoon characters are cross-eyed. Cross-eyed people are stupid, and that's why it's OK to make fun of them. I'm joking again. The truth is, cross-eyed people can't see your cartoons clearly. And they can't shoot straight.

Humor is a gift, intended to bring only joy and laughter. If it makes even one person feel humiliated, then that's a bonus.

A good rule of thumb is this: It's OK to make fun of anybody who couldn't beat you in a fight. Or sue you. It also helps if they don't have any anti-defamation league.

A Stupid Portrait Gallery

PORTRAIT #1

Isn't she perfection? I wonder who picked out her outfit.

PORTRAIT #2

Whaddya think? Is he a world-famous
quantum physicist or an idiot?

PORTRAIT #3

You don't have to be human to be stupid. This cat's eyes and drool reveal him to be a moron.

PORTRAITS #4 AND #5

Superheroes always look like idiots. Always.

PORTRAIT #6
A cross-section is the kind of informational aid that can help people understand your character's complex inner workings.

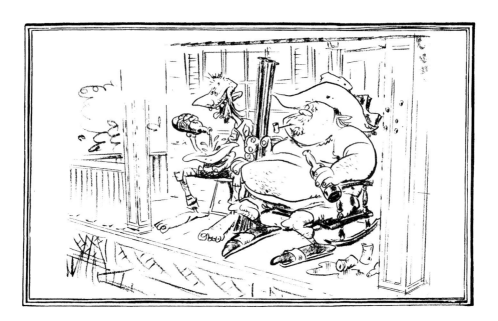

PORTRAIT #7
The poor. Ignorant, therefore funny.

Stupid People Do Stupid Things

Show your character doing something stupid. Character is revealed through action, not dialogue. Some people's actions contradict their words. Saying, "The check is in the mail" doesn't make it true. And just because a character says something dumb doesn't make him dumb. You've got to show me the dummy!

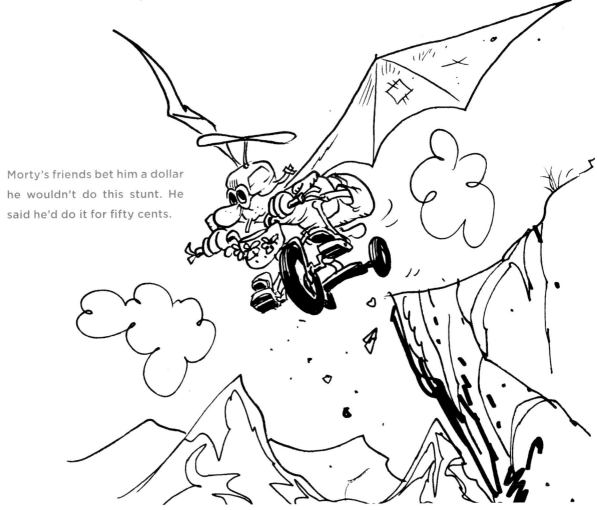

Morty's friends bet him a dollar he wouldn't do this stunt. He said he'd do it for fifty cents.

HOT TIP
Draw your characters thinking before doing something stupid. That makes them seem even more stupider!

14

Write a Story

Introduce a character. Make the audience like him. This is most easily done through misfortune—maybe he locks himself out of his car while a pretty girl is watching. See? You automatically like the character.

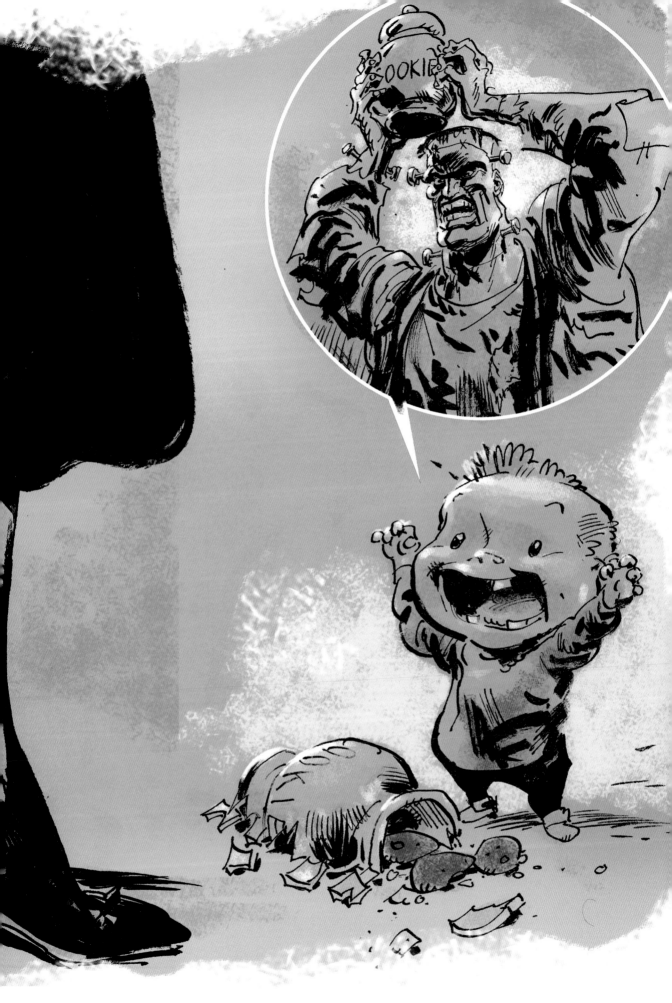

Another easy technique is to make the main character similar to the intended audience.

Books for children often have main characters who are children or teens. Women like stories about women. Spider-Man was a high school wimp. (What does that tell you about the comic's audience?) If you open a story with a scene of your protagonist walking through town while the neighbors all smile and wave, your viewer will assume the character is pretty well-liked already, and probably OK in that case.

Once you've established rapport between your audience and protagonist, give the character a goal. Have the character try to reach that goal, encountering obstacles along the way. Have things get worse. Make it seem like the character is going to fail and that all hope is lost. Then, just when it looks like there's no chance for success, have the character win. The end.

Be Interesting

Nobody cares about you. I doubt a comic book about the recent breakup of your romantic relationship would be very entertaining. You know who's going to read that? Lonely people! You know what's wrong with lonely people? No word of mouth!

Think about your audience, and work to make your story clear and entertaining for them.

People care about characters and stories. The drawing style—even the quality—doesn't matter so much. What matters is that your pictures contain information that moves the story forward. The main character needs to be someone the viewer wants to hang out with. Even the villain must be watchable. The villain is often the most fun to do, because it gives you an opportunity to be creative within a formula. I always focus on the emotions and the characters and moving the story forward. You should, too. Don't get lost in the drapery.

If one of your characters isn't really a character, drop him. If part of your story isn't really part of *the* story, cut it. Really.

The ending needs to be spectacular. The beginning, too. If both the beginning and the end are rock solid, you can hack your way through the rest of the stuff. Nobody ever remembers the middle.

Sharpen the Contrast

Try to generate at least two conflicting emotions. Be funny with a sad part, or tell a scary story with a happy ending. Mix romance with comedy. Excitement with fear. Depression with uplift.

Make the viewer feel something. Anything, really. Just make it clear up front what you're selling. The cover to this book, for example, promises fun cartoon instruction, and it delivers. If the cover image looked like the horror image at the right, but inside you found the bunny above, you'd be disappointed.

And remember, you need some conflict, because otherwise you'll be tempted to have a message. ATTENTION, CARTOONIST! You are an entertainer, not a messenger. If I want a message, I'll turn on the TV and listen to some pundit tell me something I already know and agree with.

Make Your Characters *Act*

Scott McCloud, the author of *Understanding Comics: The Invisible Art*, pointed out to me that two drawings from my cartoon "Taste" contain the kind of complicated acting you almost never see in cartoons. Let's examine the whole sequence, so that everyone can do the same things in their cartoons from now on . . .

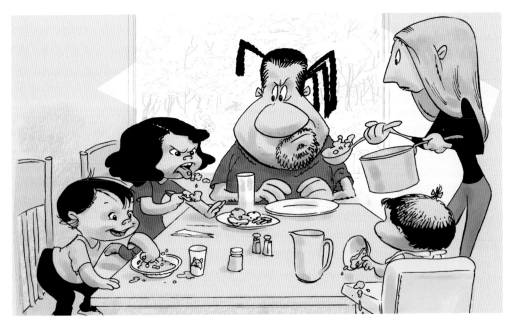

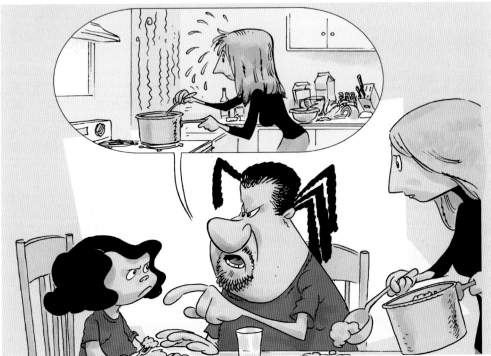

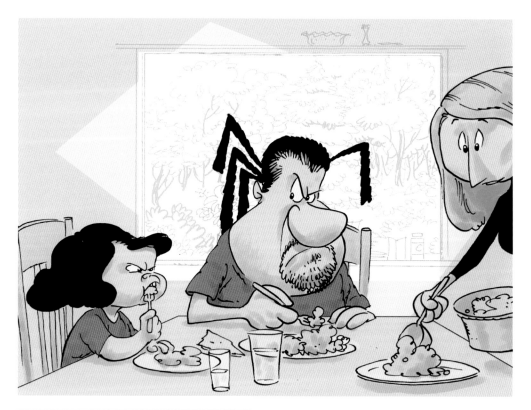

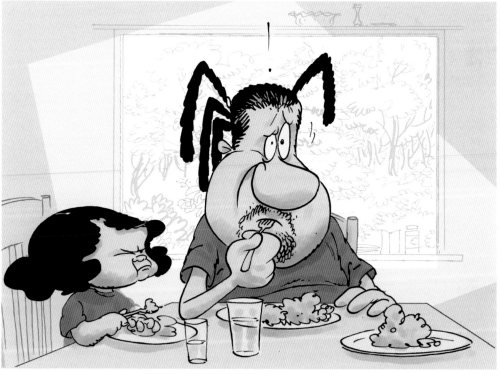

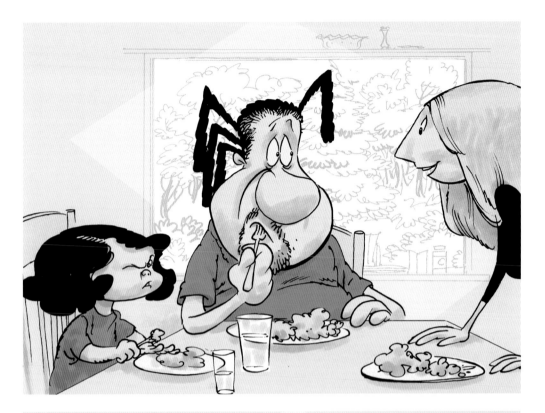

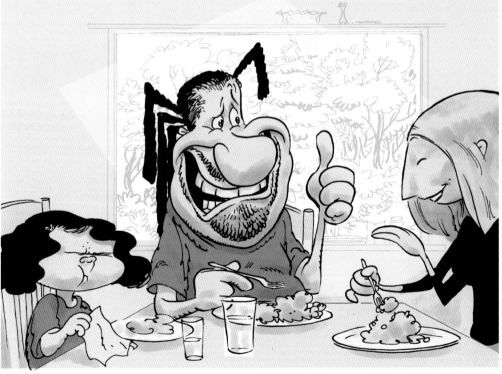

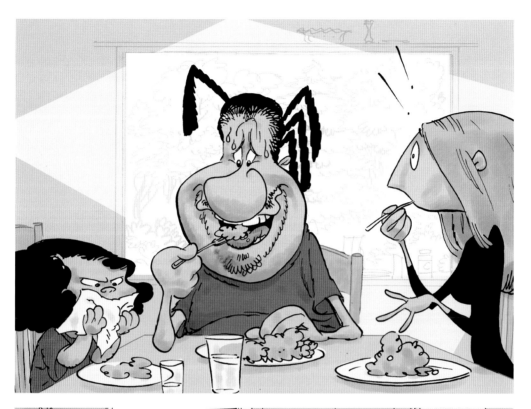

Now, let's take a look at the two frames that so impressed Scott. In the top frame, the conflict is clear, and everyone's individual personality and emotional drive are clear and readable. If you'd never seen these characters before in your life and the top drawing were the only drawing you saw, you would know immediately that this was a family at dinner, and that Mom is asking Dad his opinion of her cooking, which, judging from the kid's face, must taste pretty bad.

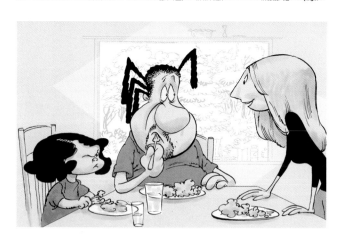

Mom's posture indicates that she's eager for the praise she's clearly anticipating. But now check Dad out. The cool thing about Dad is that he's feeling a number of conflicting emotions, and they're all simultaneously playing across his face. This guy is obviously in a quandary. And he is thinking. You can see him thinking, and you know exactly what he is thinking at that moment. Making your characters think is what makes them come alive.

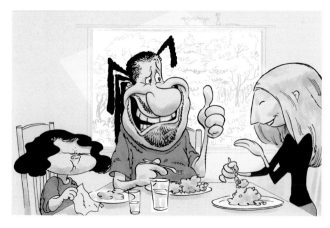

What you read in Dad's face is *not* one of the four stock emotions—happy, sad, angry, scared—that you'd find on a typical cartoon model sheet. No, this character is displaying a specific emotional state that's *specific to the situation*, and he's playing it *in character*. What that means is you can look at this drawing—even without text—and tell me who these people are and *what kind* of people they are.

Now look at Dad's face in the second drawing. Again, this is not just a standard, stock "happy" expression. The dude is *lying*! His expression shows conflicting emotions that are specific to the moment, the character, and the situation!

Mom's reaction is also in character. Dad would never use the kind of body language she uses. Her reaction tells us something about her just as his actions tell us who he is.

Your goal in entertainment is to generate an emotional state in the viewer. Using a facial expression is the easiest way to change someone else's emotional state. When you smile at someone, they smile, too. You frown, they frown. Meryl Streep cries, the whole theater cries.

That's why it's good to have as much control as possible over your drawings of faces. You want to be able to create as many emotions as possible.

Create Suspense

Suspense is when nothing happens. Yet.

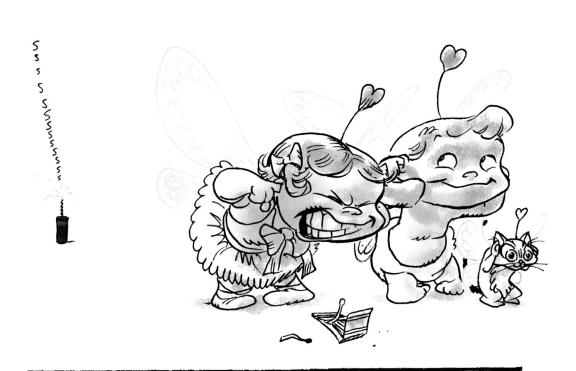

See? Nothing.

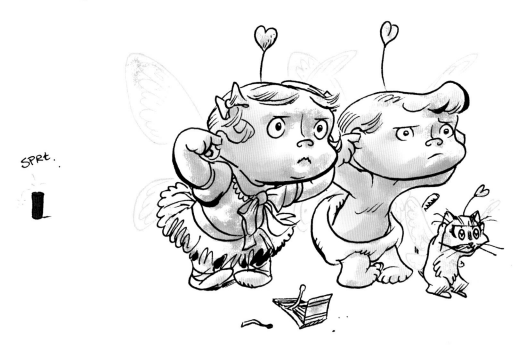

Suspense is nothing happening, but your palms still get sweaty, and your pulse still races. The fear glands are pumping adrenaline and whatnot through you, which is the point. You want to feel something.

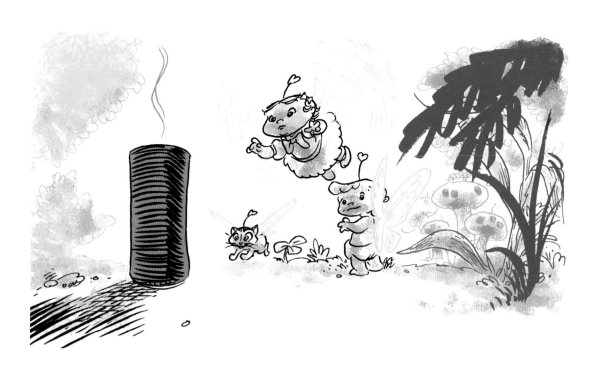

Characters are what they *do*. Look at what's changed as we move from the earlier drawings to these.

The goal is *communication*, and communication is accomplished through *exaggeration*.

Here and in the previous pictures, you can clearly see the characters thinking. Still, nothing is happening. But you're interested. The longer nothing happens, the more you're on the edge of your seat.

Now, this scene would be completely devoid of suspense if the characters were repulsive, instead of cute, and if you knew all along that this was not a real firecracker but a harmless Pixiecracker full of Precious Pixiedust, which it is.

Precious Pixiedust is harmful only to rats.

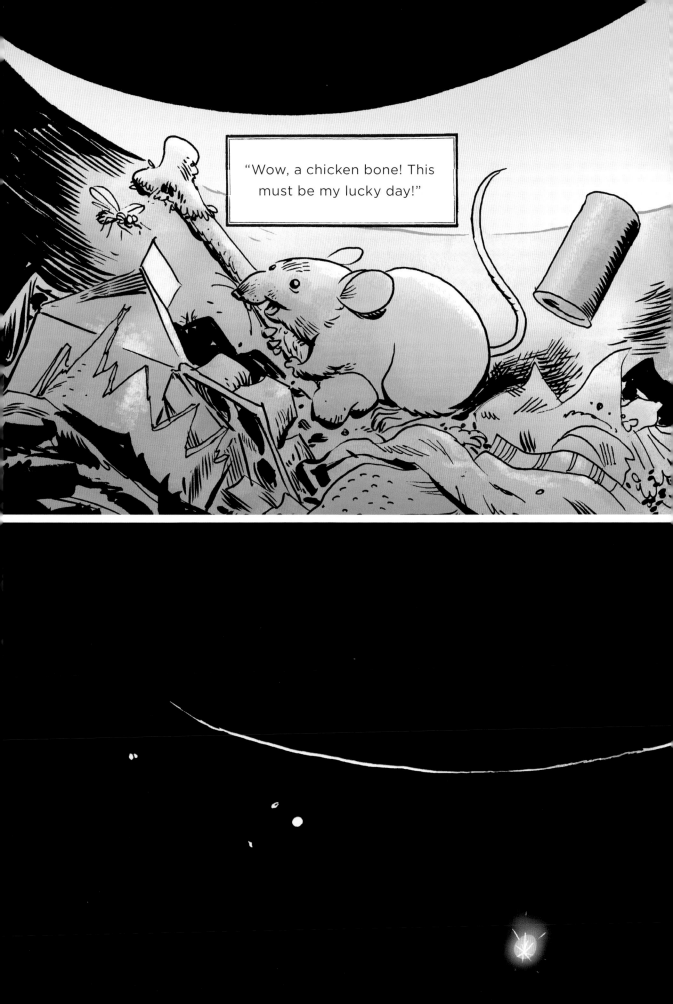

The suspense is finally broken.

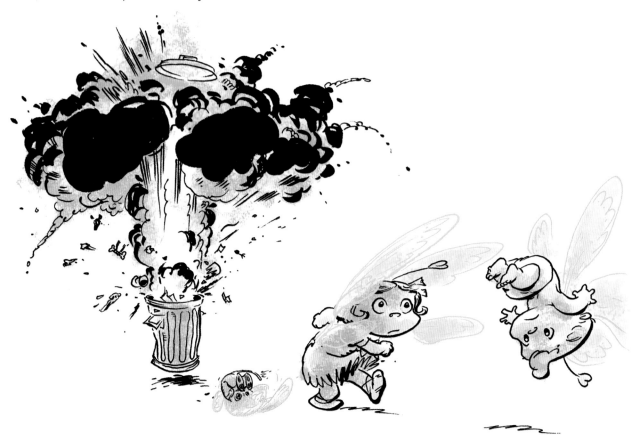

EPILOGUE

Don't Wait!

Sure, it's great when a corporation gives you money and mass-produces and distributes your cartoons . . . but sometimes that just doesn't happen. Don't let that stop you from getting your cartoons seen! These days, it's possible to produce and distribute your cartoons via all sorts of means: DVDs, podcasts, Web sites, blogs, print-on-demand books—you name it.

If you're into animation, it's easier than ever to do your own, low-budget animated cartoons while you're waiting for Hollywood to give you that $100 million for your feature-length film. Whatever you do, keep it short! You'll be amazed at how much work is involved in making just one minute of animation. To compensate for lack of animation, use some of the other storytelling tricks and techniques discussed in this book—things like the "subjective camera," making your characters really *act*, and antics. Big contrasts are easy to read, so use big antics for limited animation.

And, finally, *be the best*!

You know why my books are always late? Because if it's not the best book of the year, I don't publish it. And you know why I'm the best? Because I *say* I'm the best. If you say you're the best, that's it. Try it.

If my cartoons aren't fresher and funnier than everyone else's, I throw them out. If my graphic novels aren't on the cutting edge, they don't see the light of day. The first thing I decide is that "Kyle Baker" means *the best*. That's why I win awards.

Being the best isn't an option these days; it's a necessity. You don't have to be competitive, but you must be the best. There's room for everyone to be the best. There are a lot of best cartoonists out there, aren't there? I have about fifty favorites!

The world moves faster every second. You have to grab people *immediately*! There were 80,000 other books in the store where you bought this. Your eye scanned the covers, spines, and titles of all those books and you picked this one. Why?

Because I promised you something you want. You wanted to know my cartooning secrets. And I gave them to you.

People show me cartoons all the time and immediately start apologizing for the poor quality. If you know it's bad, why are you showing it to me? Make it better. Do what it takes to make it better.

Or throw it out and make a good cartoon. It's just a freakin' *cartoon*! It's not the Sistine Chapel!

Decide to be the best cartoonist and stick to it. If the drawing is bad, tear it up. If the joke's not funny, make it funny.

CONGRATULATIONS!

YOU'RE A CARTOONIST!

Index